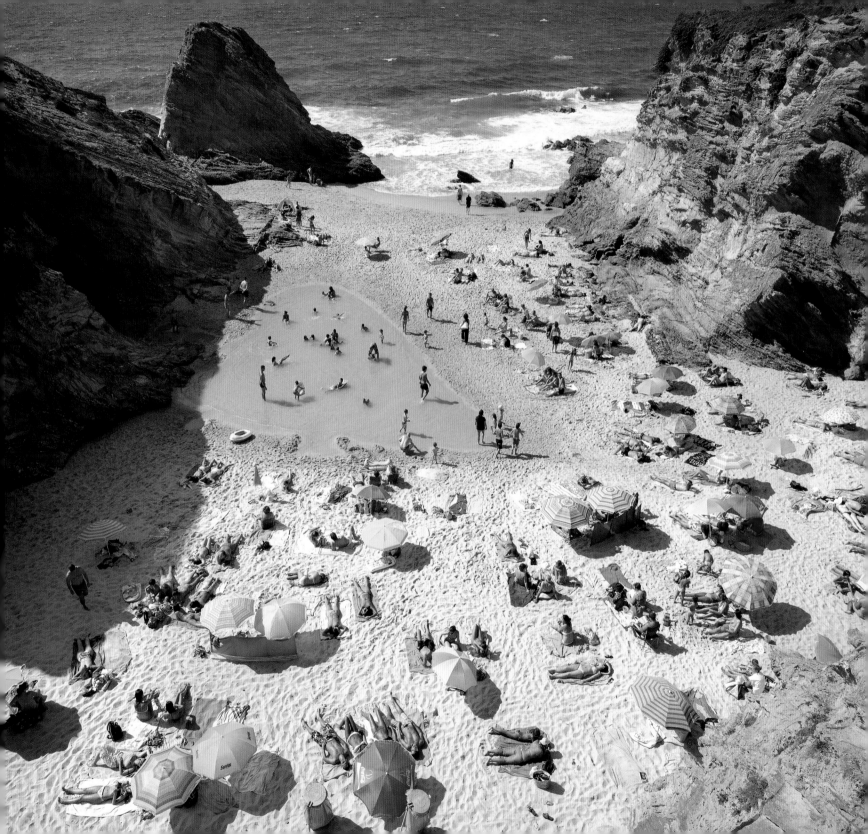

summertime

edited by joanne dugan

CHRONICLE BOOKS

SAN FRANCISCO

Library of Congress Cataloging-in-Publication Data available.

ISBN: 978-1-4521-2479-7

Manufactured in China.

Designed by Sara Schneider.

10 9 8 7 6 5 4 3 2 1

Chronicle Books
680 Second Street
San Francisco, California 94107
www.chroniclebooks.com

● For Ludovic and Hugo, my summertime

introduction

It turns out that my first summer love was not a person but a place. My earliest memories of the season are at the water's edge, first at the ocean in Rehoboth Beach, Delaware, a typical East Coast boardwalk tourist town, and then later on the bay in the Cape Cod town of Orleans, Massachusetts.

I spent most of my childhood summers in the first town, but remember the second much more clearly. I recall gazing at the horizon right outside the door of our splintery vintage beach house, set near the edge of a beach called Skaket. The dramatic shifting tides in front of us changed twice every twenty-four hours, like clockwork. There weren't any clocks that I can remember— it was the rhythm of the water that gave those loose summer days structure as we sat on the water's edge waiting impatiently for the show to begin.

During the shift to low tide, the water would rapidly roll past our line of sight, mysteriously disappearing more than two miles out—exactly where to, we weren't quite sure. Once a day and sometimes also in the not-yet-dark evenings, we would find a just-made beach, covered with a tapestry of tide pools that served as perfect, child-sized animal viewing stations. The pools were filled with young hermit crabs, silvery minnows, and transparent glass eels, and they all seemed a bit shocked that their habitat had changed in less than an hour from being six feet below water to just a few inches.

We dashed from pool to pool, staring down at the multiple sets of eyes that seemed to follow ours, each species contemplating the movements of the other. Sometimes we stepped into the pools without looking and leapt out when a crustacean decided to hook onto our toe, or we stumbled onto the jagged shell of a horseshoe crab, primordial with its spikes and armor. We filled up buckets with various members of this wet menagerie, keeping them just long enough to

look at and touch. I remember the miniature crabs that would stay still, corpse-like, when I placed them on my flat hand, only to watch them shake and turn in backward circles when dropped back into the temporary pools, where they had taken up residence.

Eventually, we gently poured our captures into the tide as it began to swell toward land again, and both the pools and their former tenants disappeared into that shifting, growing sea. As we walked back to our house in the dusk, we turned and faced the ocean to see that the mirrored surface of the water had picked up the hues of the sunset sky. The lines between land and sea blurred in front of us and only then did we let ourselves leave, mostly because we knew that another version of the same scene would be waiting for us the next morning.

This image sits clearly in my memory. Some years ago, I decided to revisit Skaket, and this joining of my childhood past tense with the adult present one proved to be immensely satisfying. Even though I am now a staunch city dweller, I still remain at my happiest, or at least my most inspired, when on Cape Cod. I think less about the exact place I am in and more about how I feel when I am there.

After talking with many photographers and writers about the theme of this book, it became clear that most of them have their own version of my story somewhere in their memory banks. And often their most vibrant summer memories occurred at or near the water's edge. Summer and water are inextricably related.

Our relationships with summer are as varied as our relationships with each other. Some experiences are a quick fling, a mad dash, soon to be forgotten. Others, like my tide pool moments, etch themselves into our psyches forever. As adults, we tend to revisit, or at least long to visit, what we have most loved, and if we manage to arrive there again, we find comfort in the repetition.

In thinking about these deeper connections, I realized that water was the original shield that protected us from the outside world. Perhaps we all unconsciously seek this refuge again, and the warmth of summer, combined with the primal need to be sheltered, creates a feeling of comfort we can't quite explain when we sit by, look at, or touch the water. It may be this memory that keeps us returning to the water again and again in the warm days of the season.

Whether from a sagging inflatable kiddie pool, a deserted swimming hole, a rocky Pacific beach, the shores of East Hampton, or a gushing city fire hydrant, we define our summers by the water we sit by. We smell it, taste it, love near it, write about it, and cast our gaze out past it. We make important decisions near it and also use it to forget, just for a time, those things we don't want to think about anymore.

The best part of putting this book together was the realization that practiced photographers seem to intuitively connect with the deeper meanings of summertime. Their images can be profoundly universal because we, as viewers, automatically relive our own summer stories by experiencing theirs. I invited the perspectives of many talented photographers in because I felt that no single viewpoint could tell the story fully.

Summertime can be interpreted in many ways, but it takes a special skill to convey a universal feeling within an image. This book features some of those most moving, simple moments of summer as experienced near the water and caught in fractional seconds.

Each photo is a version of that tide pool love story I first felt on Cape Cod. We all have memories like this, somewhere. Water is the thread that connects our lifetime of summers. And I hope that by spending time with this book, you can access the part of yourself that still can wander, wide-eyed, through the constantly shifting tides.

—Joanne Dugan

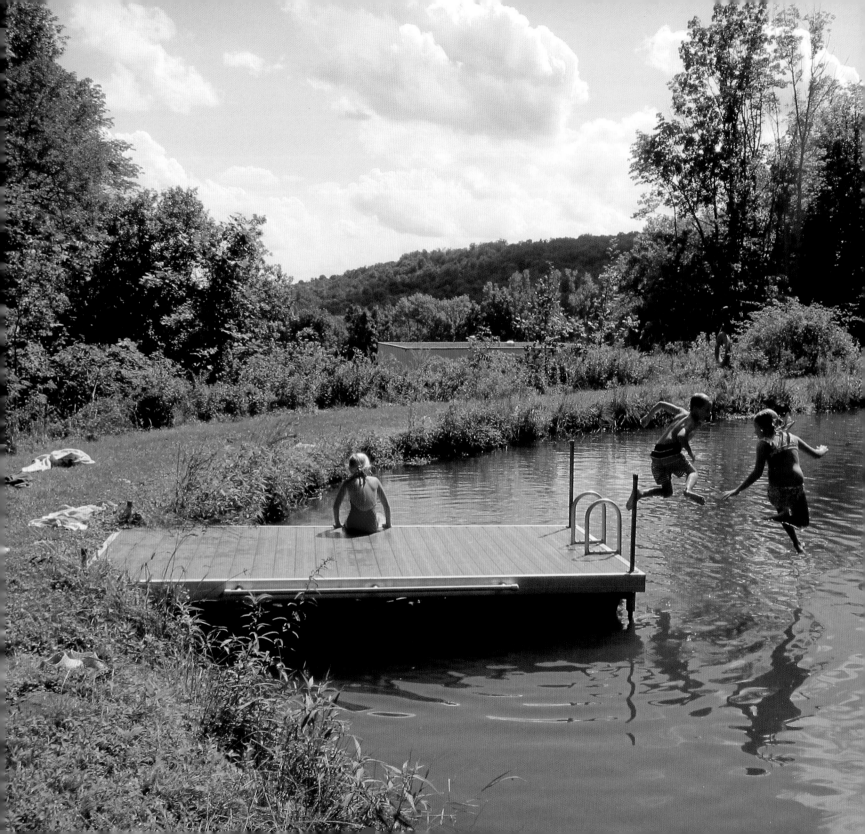

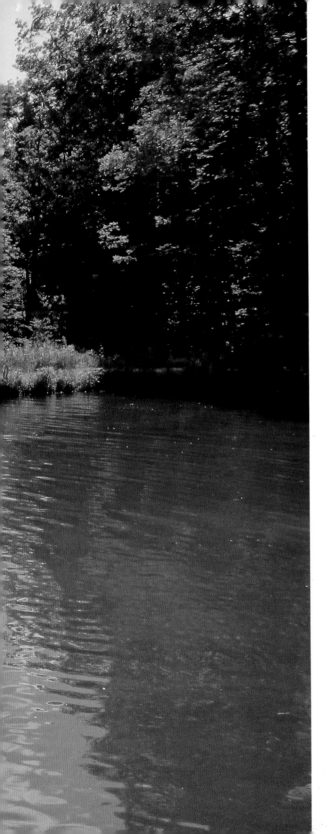

And so with the sunshine and the great bursts
of leaves growing on the trees, just as things grow
in fast movies, I had that familiar conviction that
life was beginning over again with the summer.

—F. Scott Fitzgerald

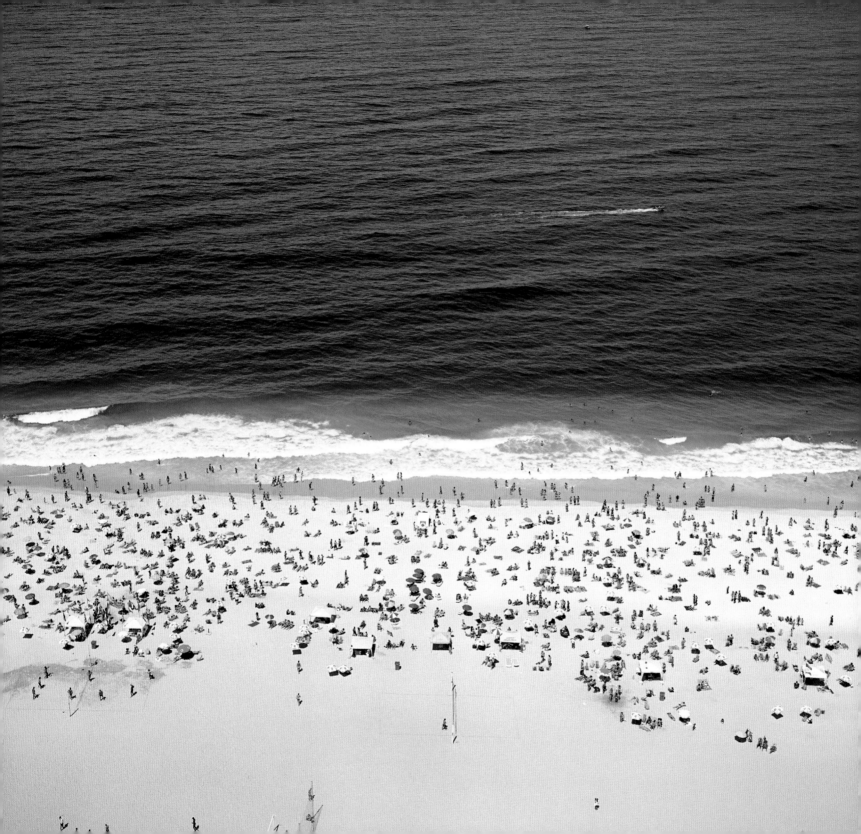

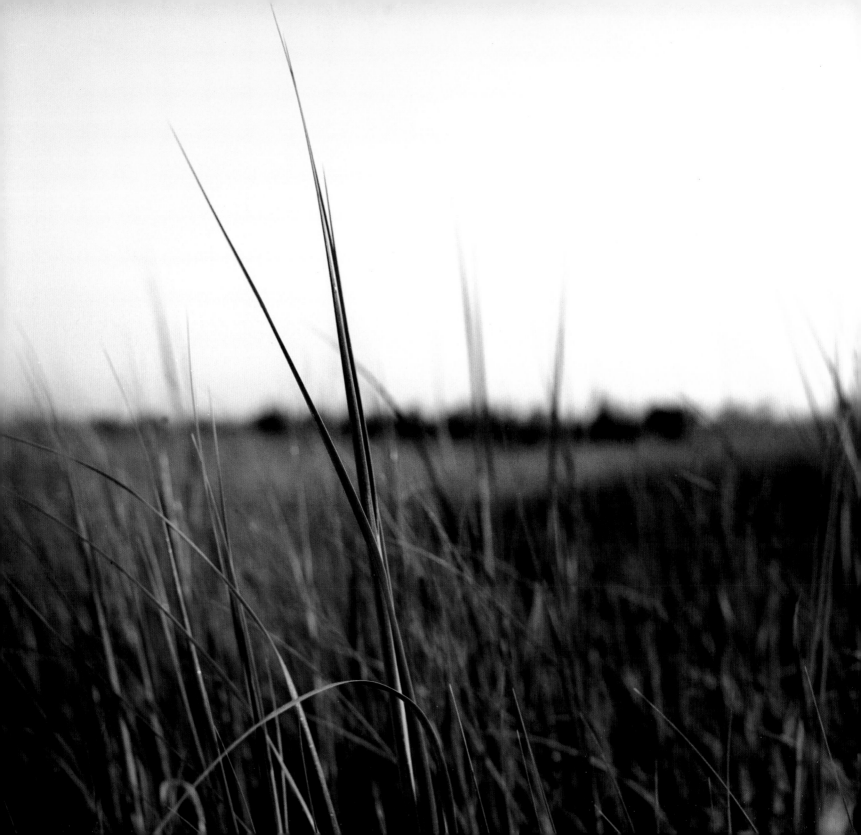

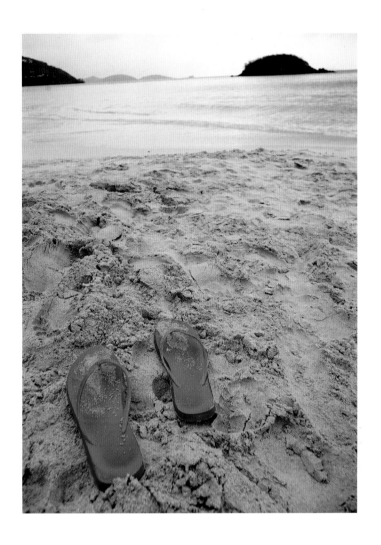

Some of the best memories are made in flip flops.

—Kellie Elmore

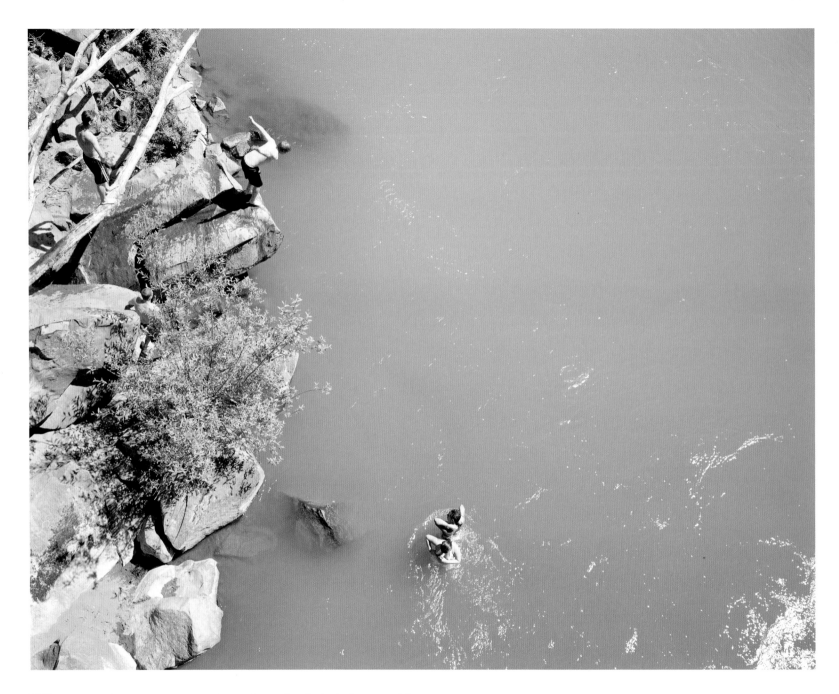

When people went on vacation, they shed their home skins,
thought they could be a new person.

—Aimee Friedman

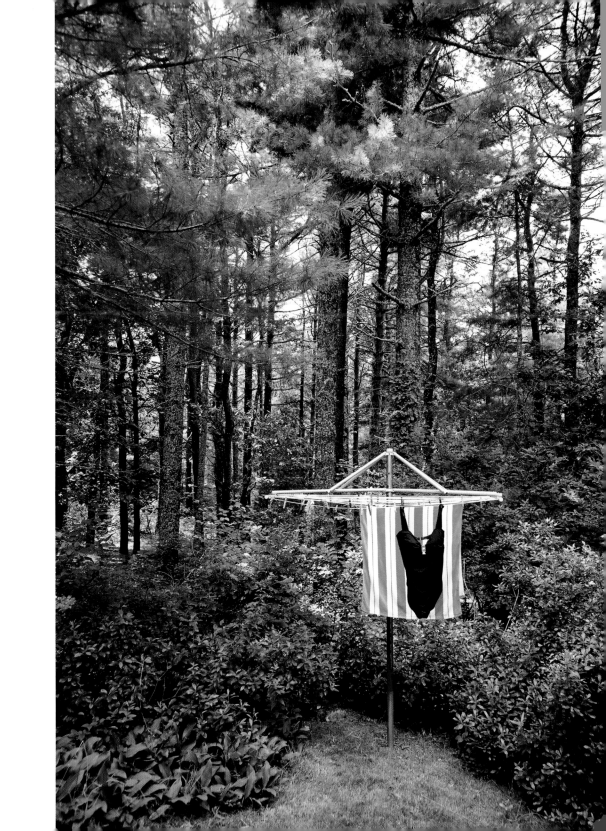

One should lie empty, open,
choiceless as a beach—
waiting for a gift from the sea.

—Anne Morrow Lindbergh

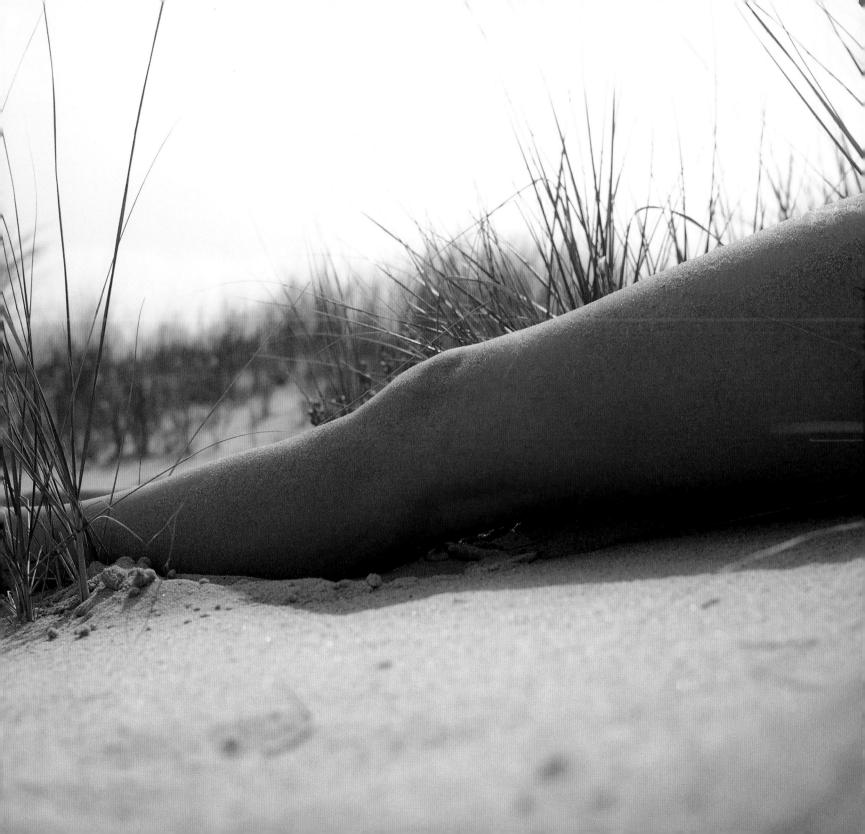

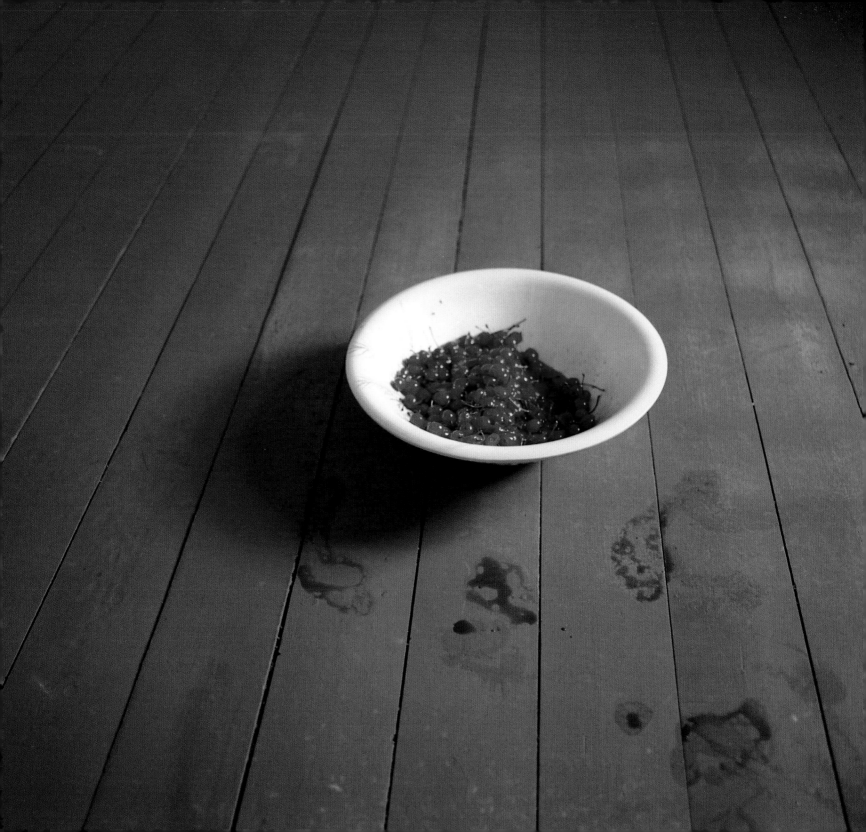

Summer was like your house: you knew
where each thing stood.

—Rainier Maria Rilke

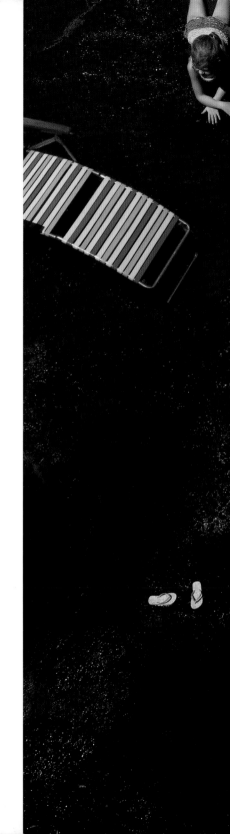

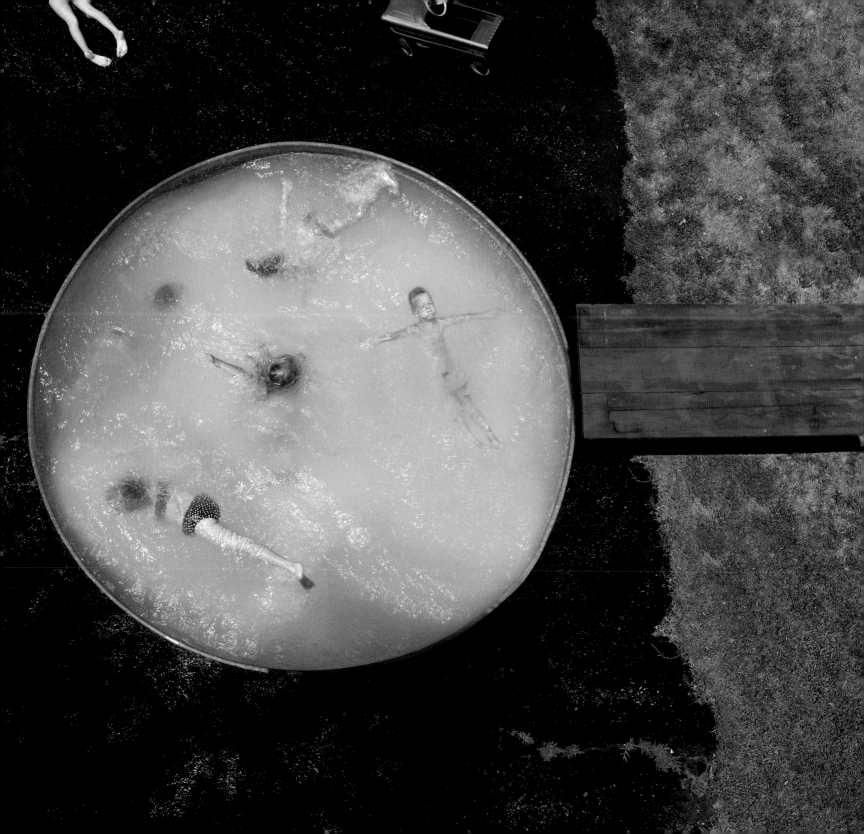

The days are open,
Life conceals no depths, no mysteries, the sky is everywhere,
The leaves are all ablaze with light, the blond light
Of a summer afternoon that made me think again of Sally's hair.

—John Koethe

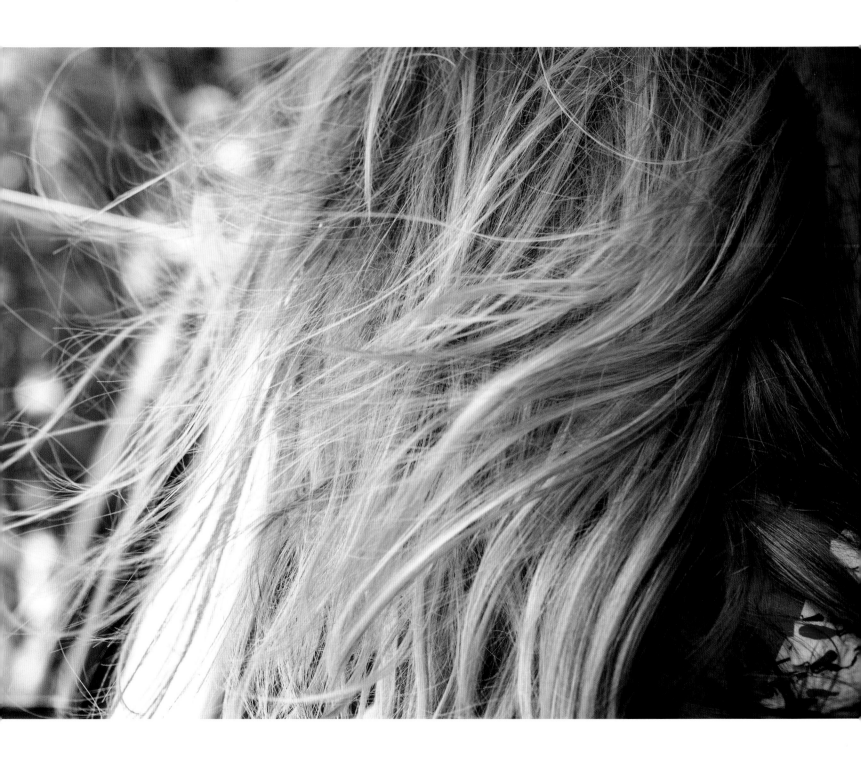

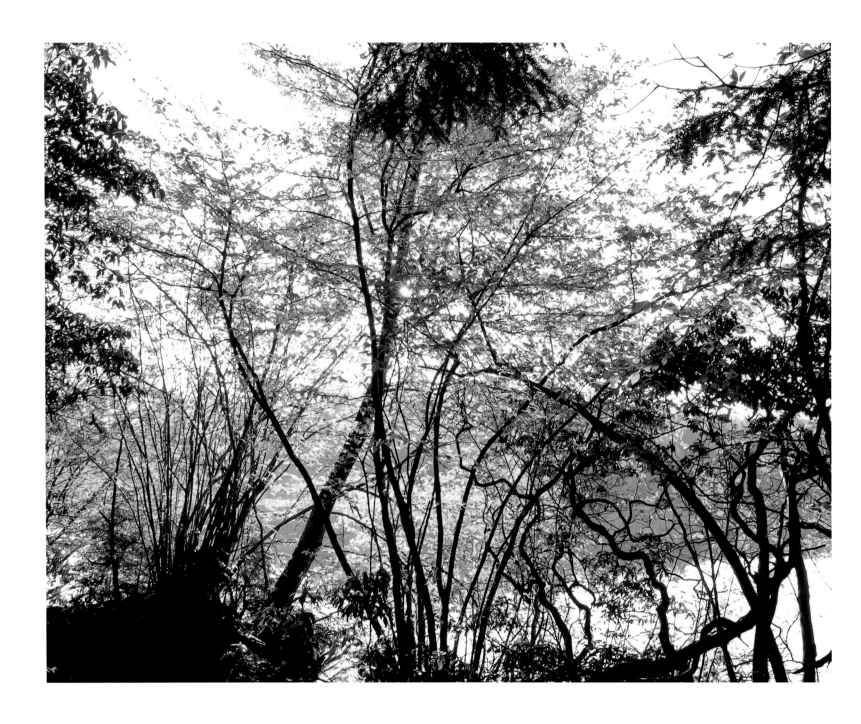

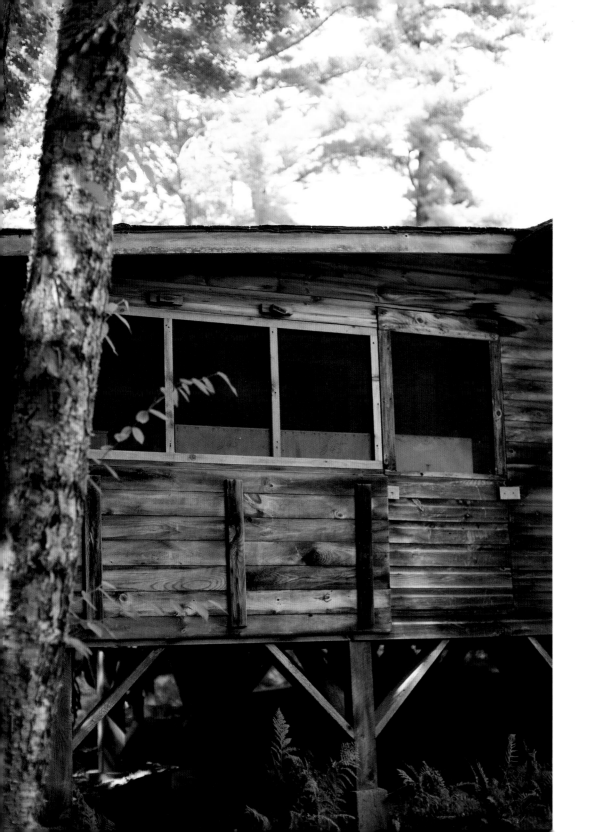

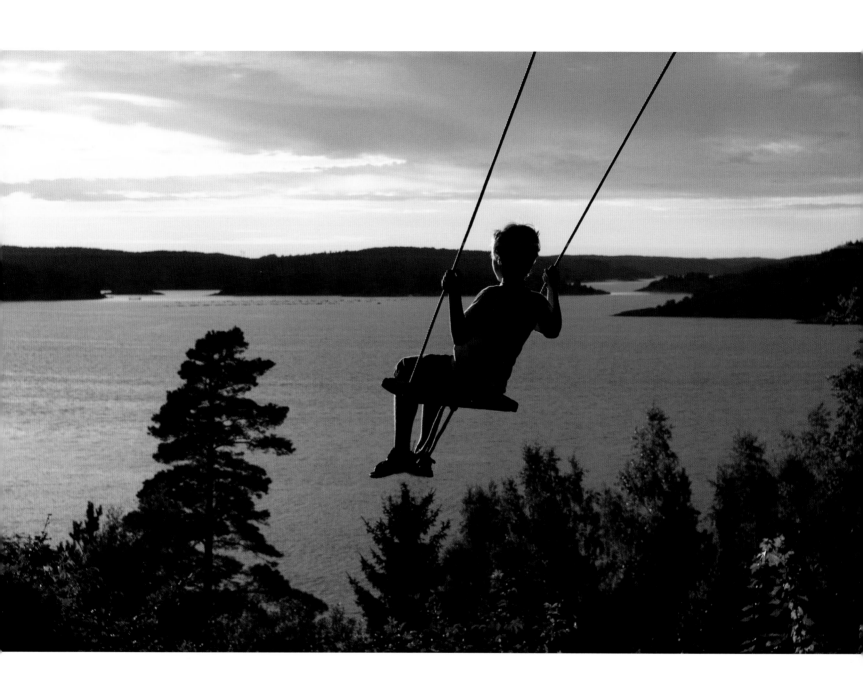

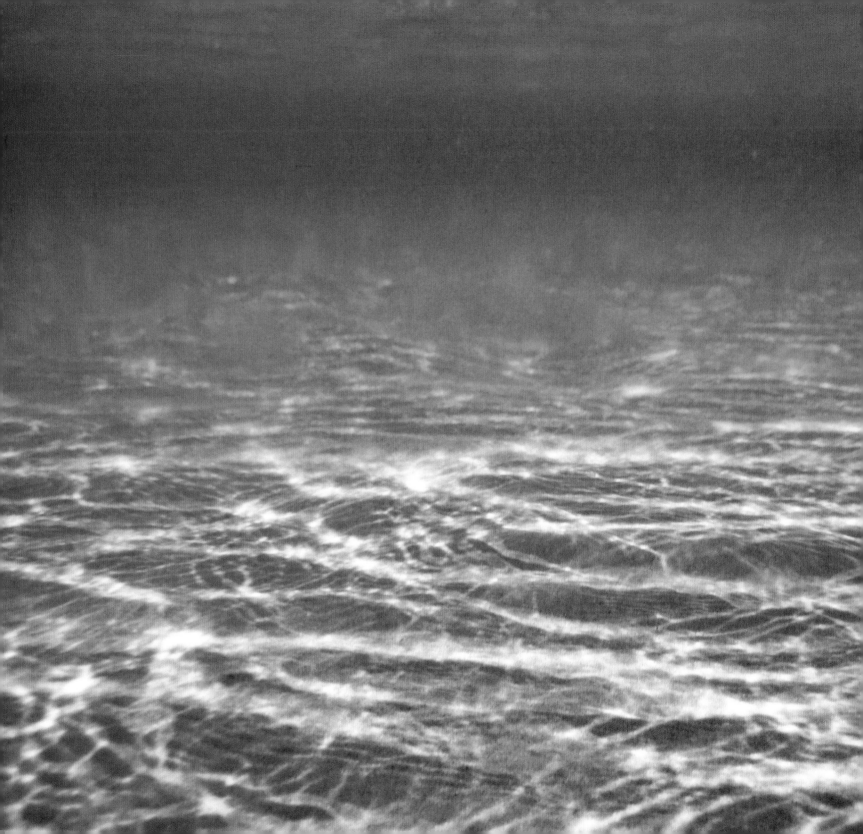

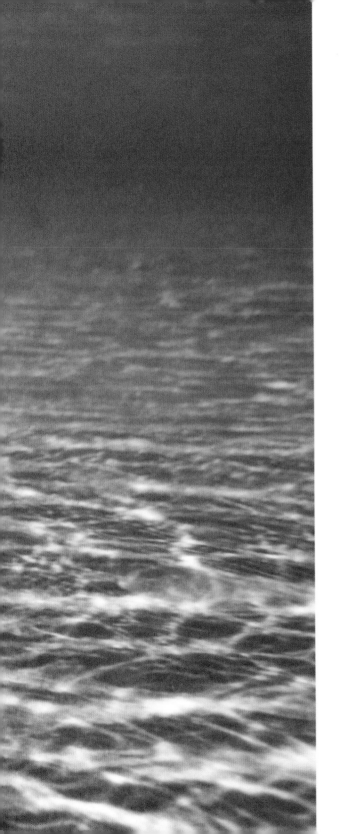

Je me suis baigné dans
le Poème De la Mer.

—Arthur Rimbaud

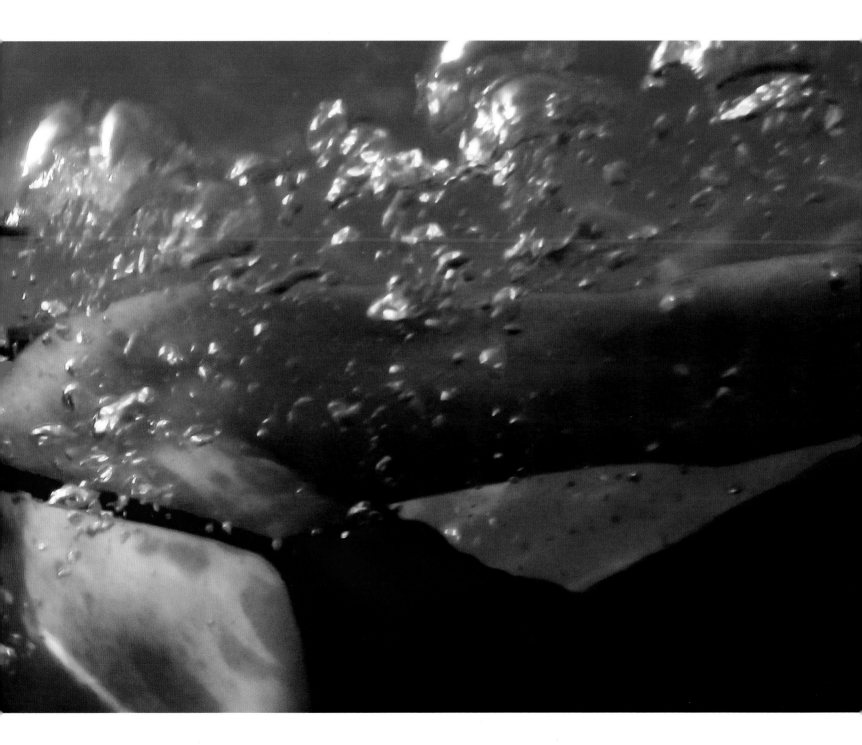

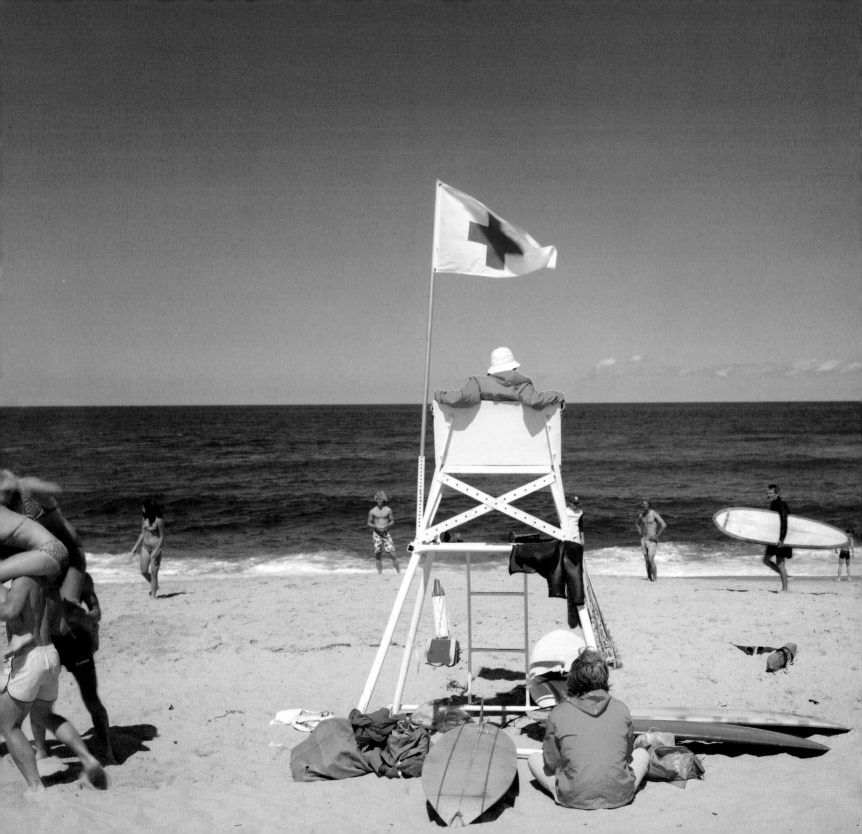

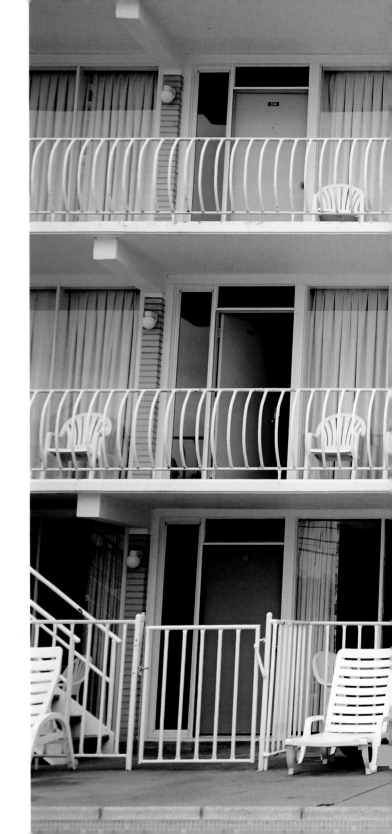

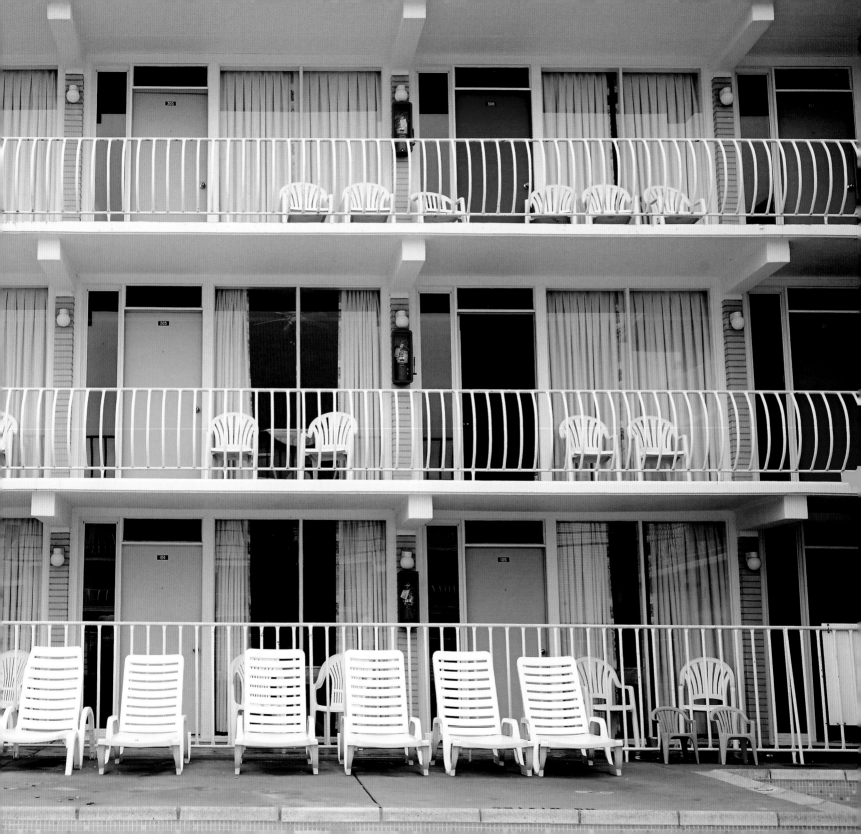

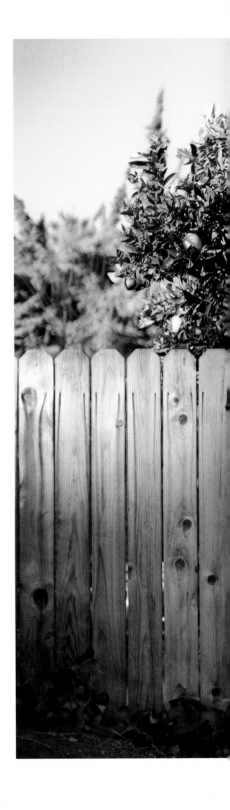

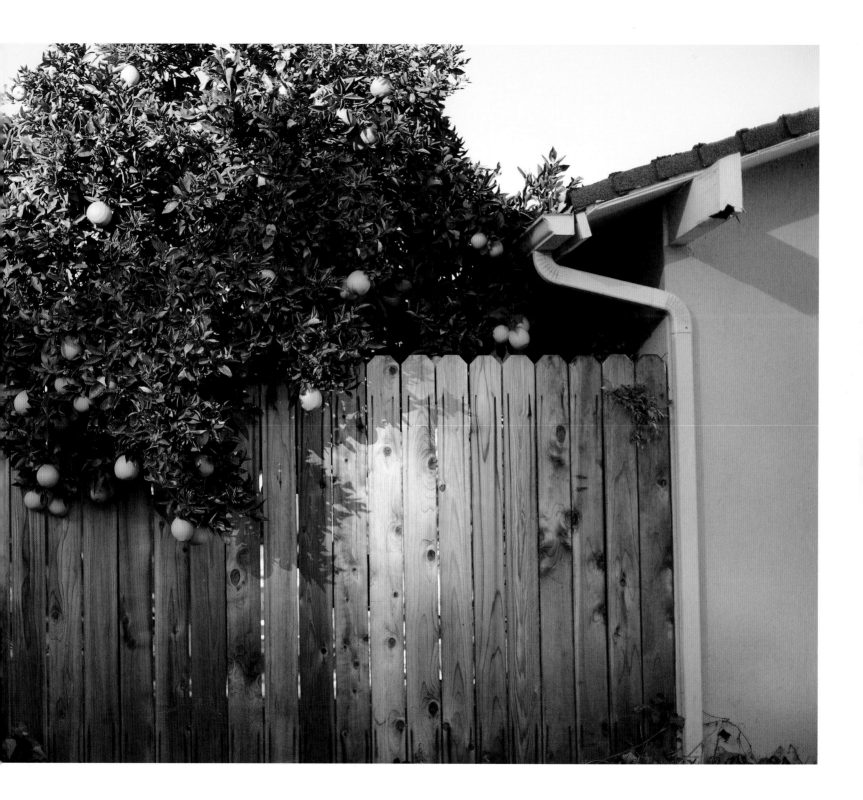

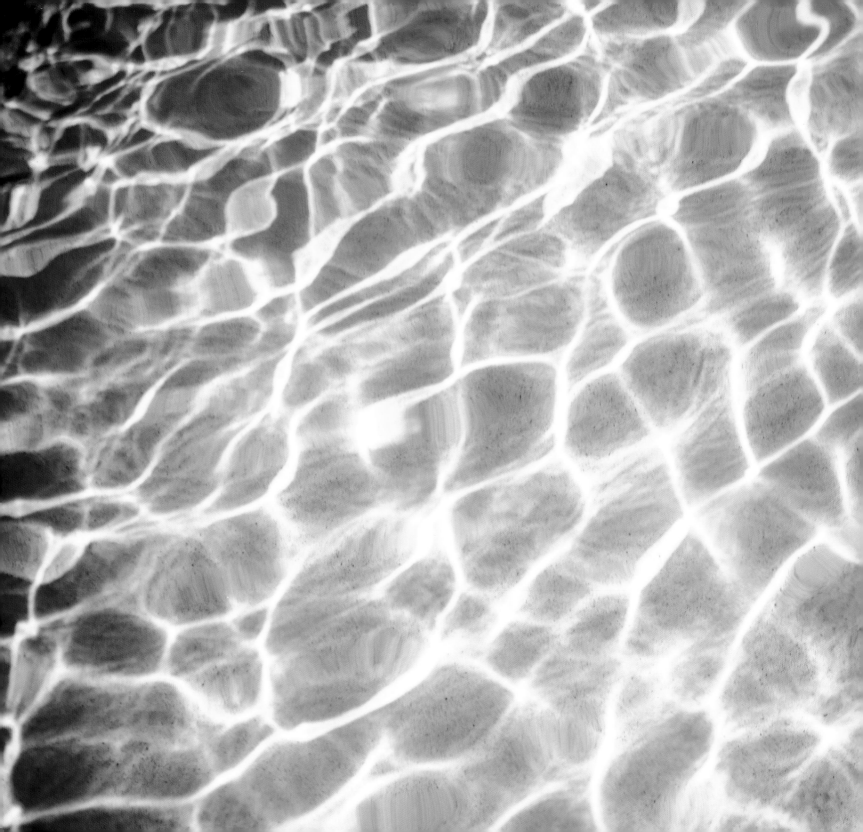

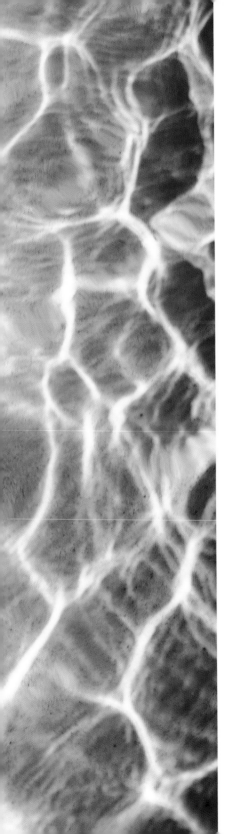

Water, stories, the body, all the things we do,
are mediums that hide and show what's hidden.
Study them, and enjoy this being washed with
a secret we sometimes know, and then not.

—Rumi

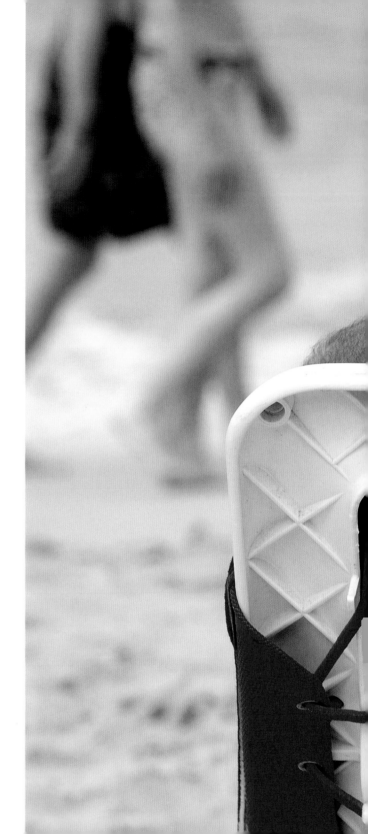

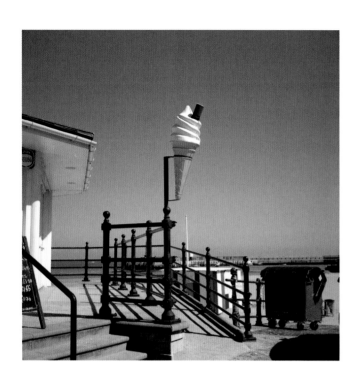

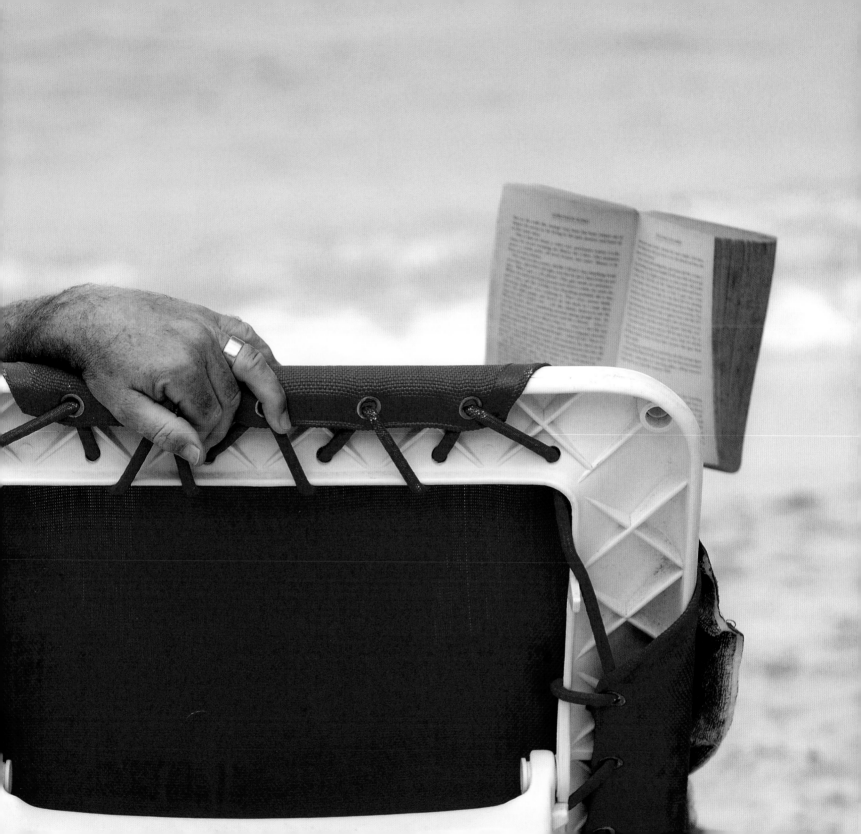

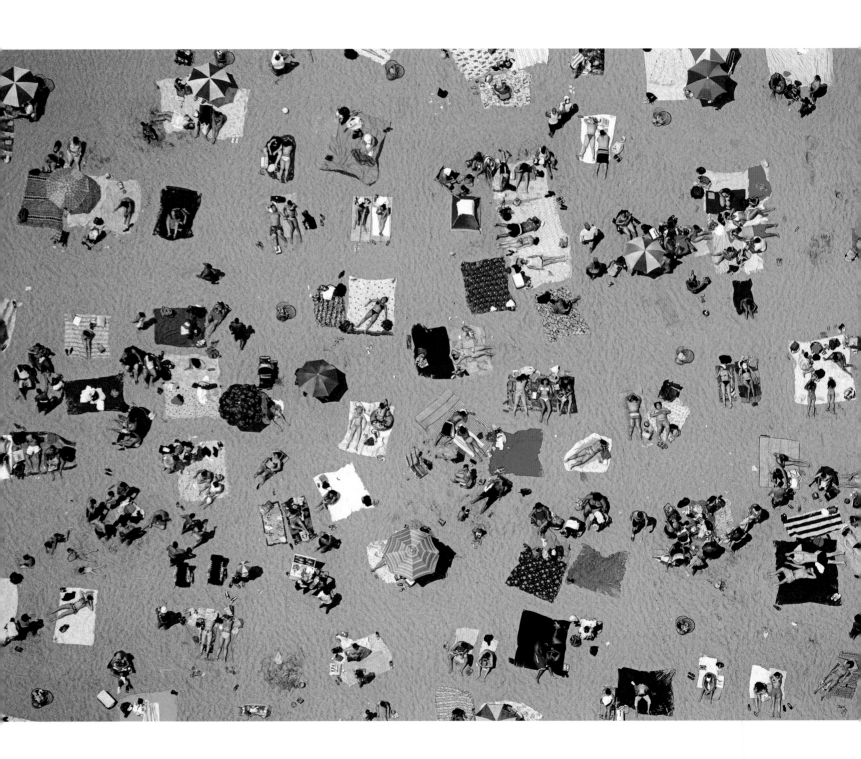

Why, this is very midsummer madness.

—William Shakespeare

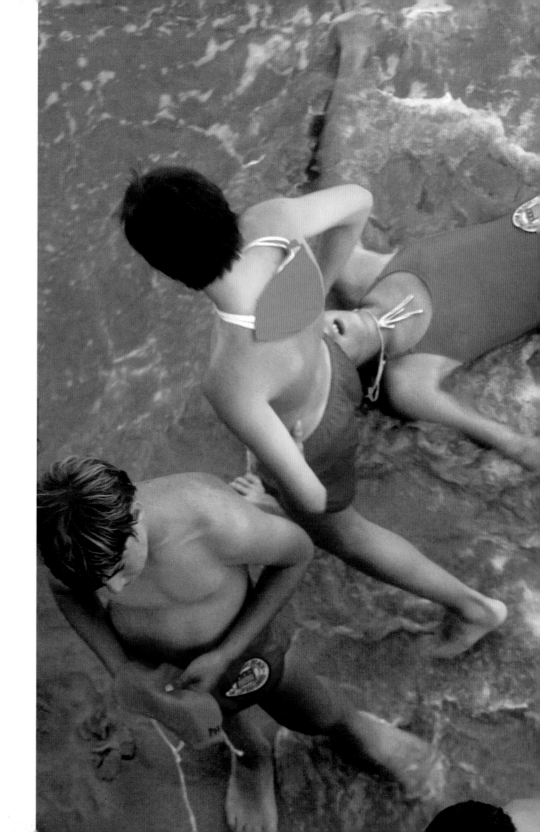

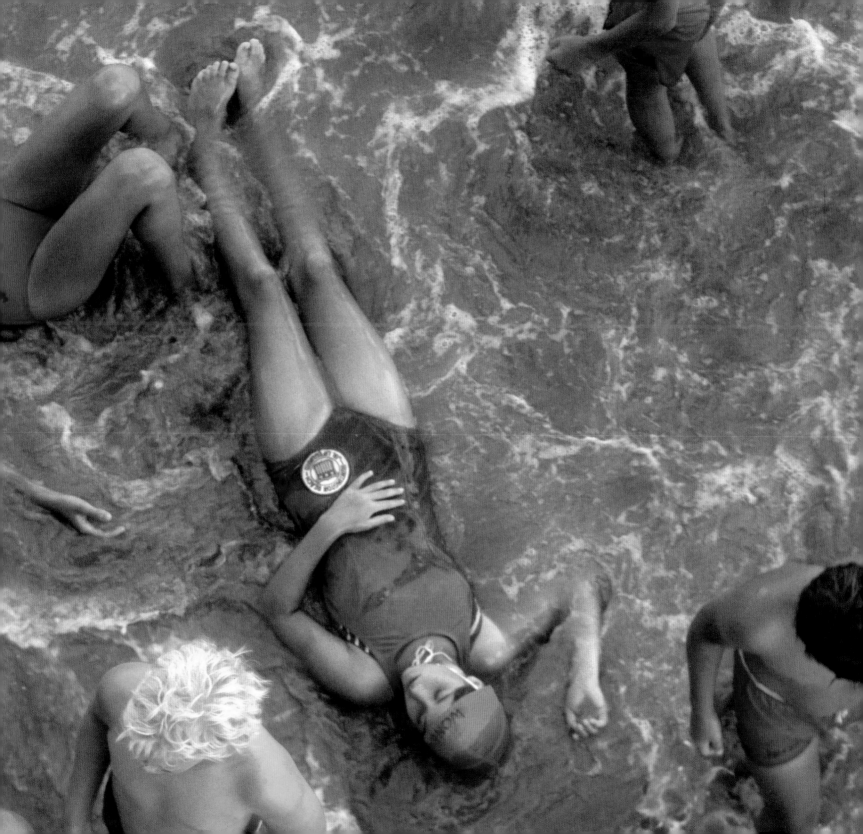

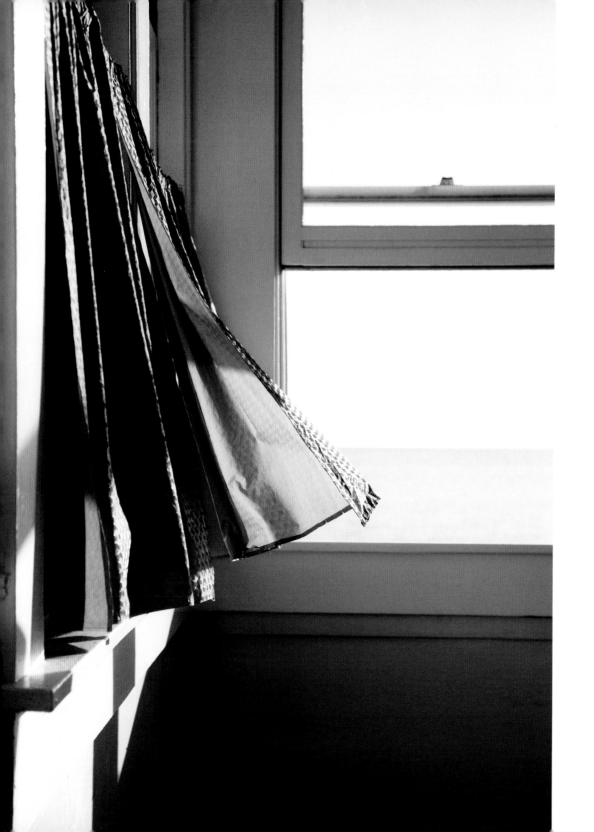

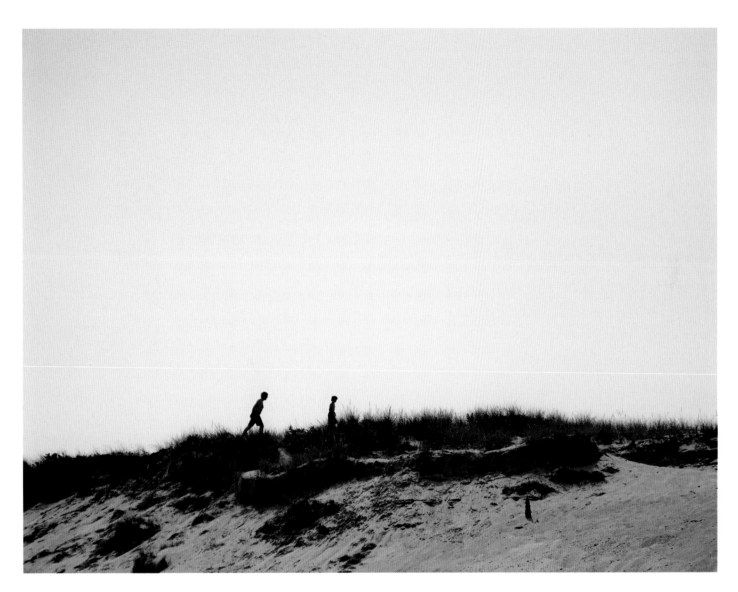

The only true voyage of discovery . . . would be not to visit strange lands but to possess other eyes.

—Marcel Proust

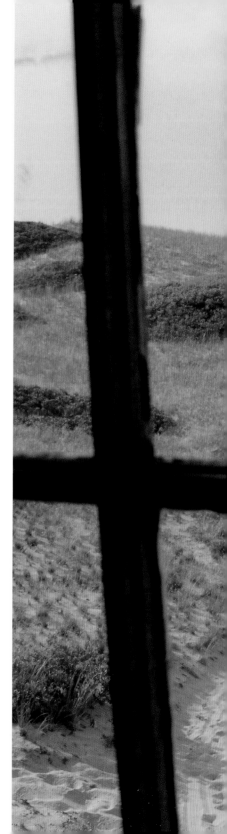

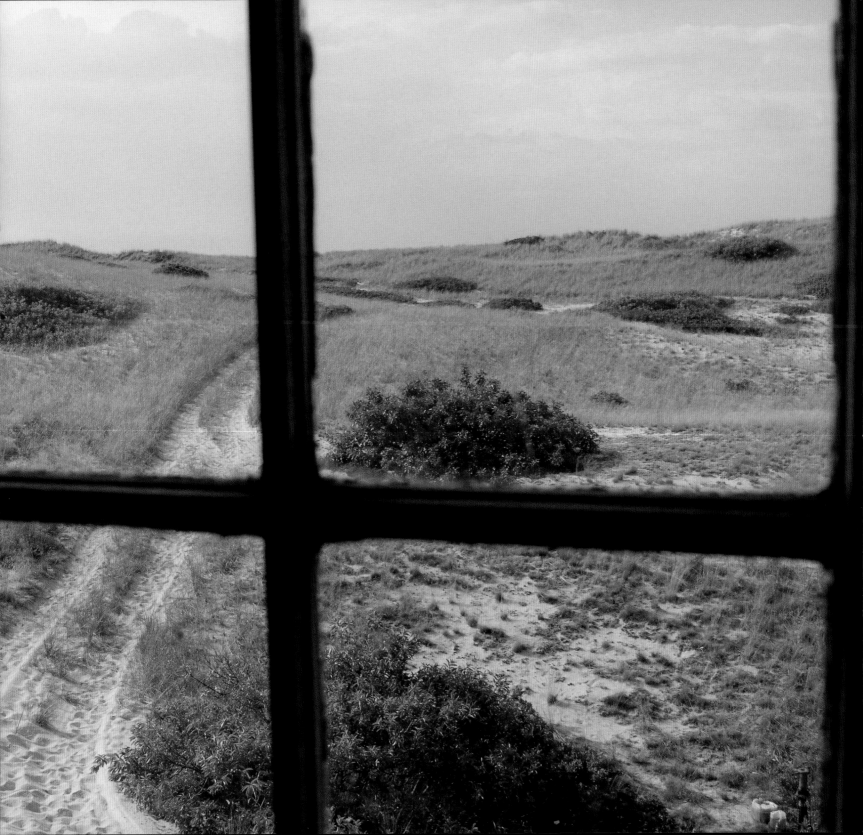

A single sunbeam is enough to drive away many shadows.

—St. Francis of Assisi

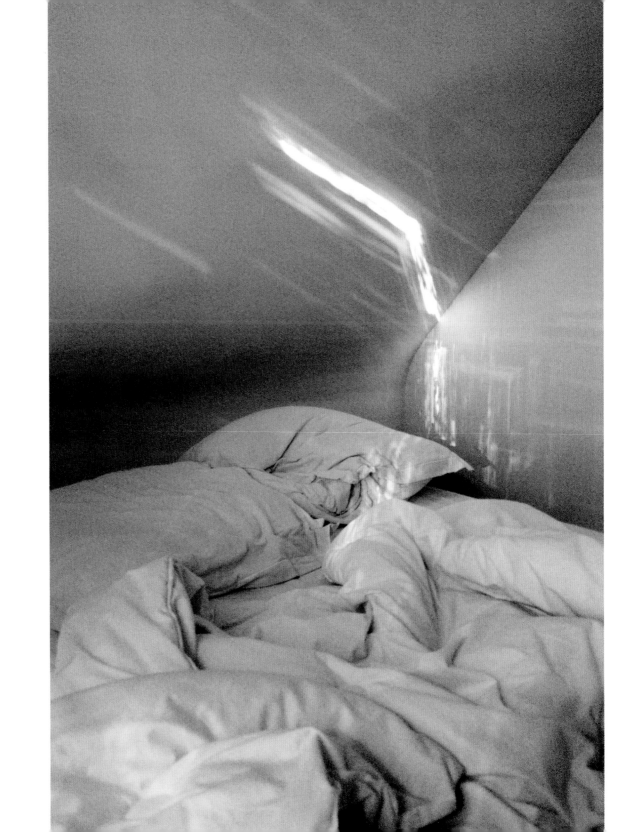

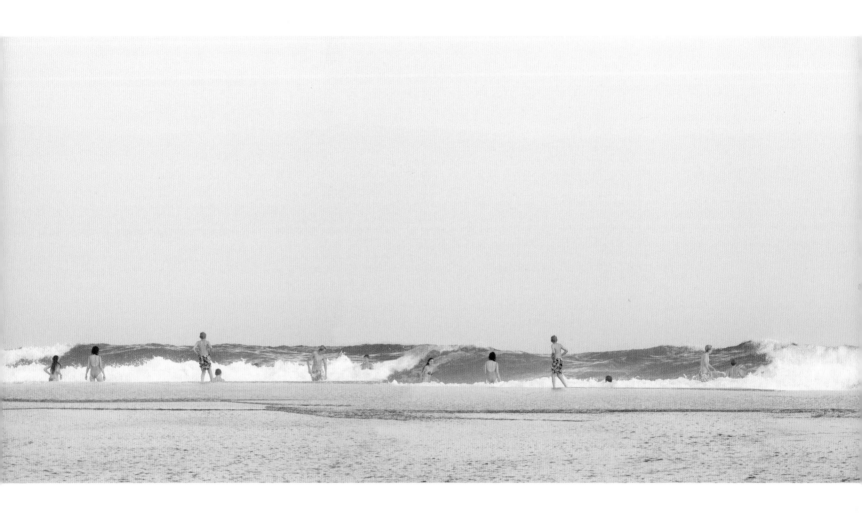

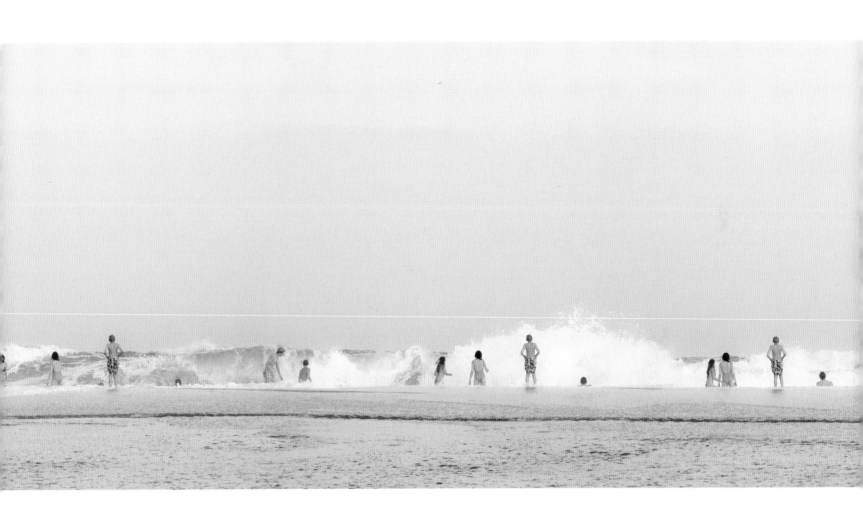

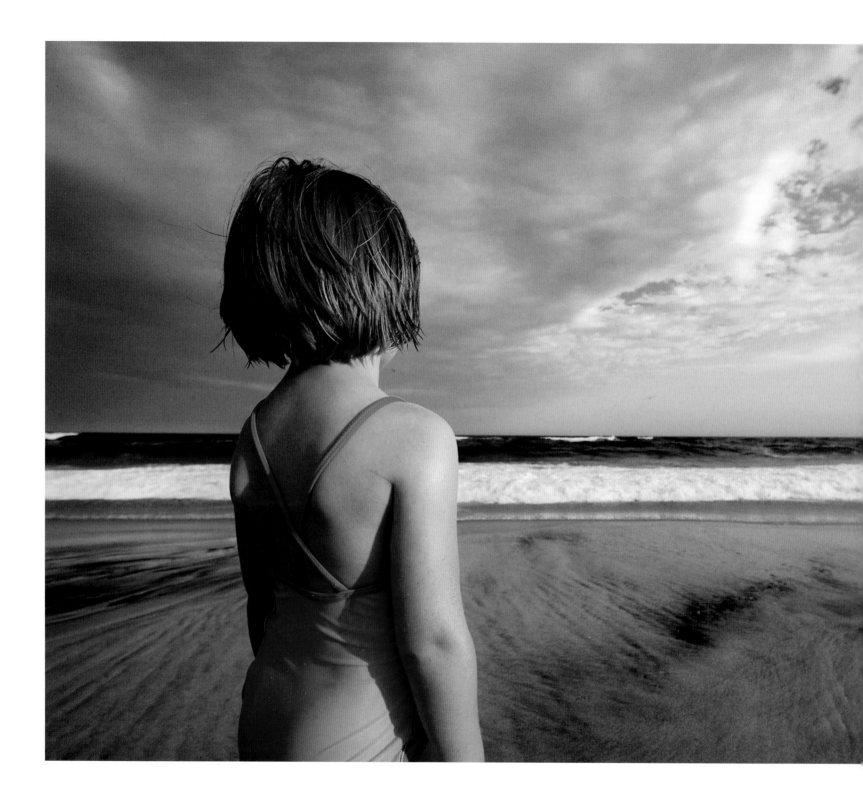

Then followed that beautiful season,
. . . Summer. . . !
Filled was the air with a dreamy and magical light; and the landscape
Lay as if new-created in all the freshness of childhood.

—Henry Wadsworth Longfellow

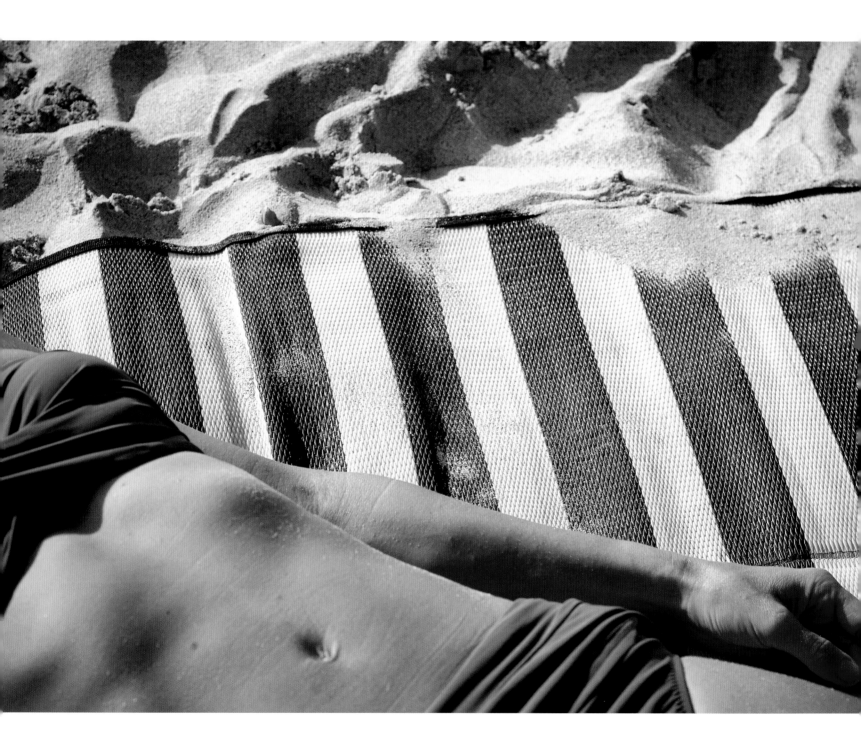

Who looks outside, dreams; who looks inside, awakes.

—Carl Jung

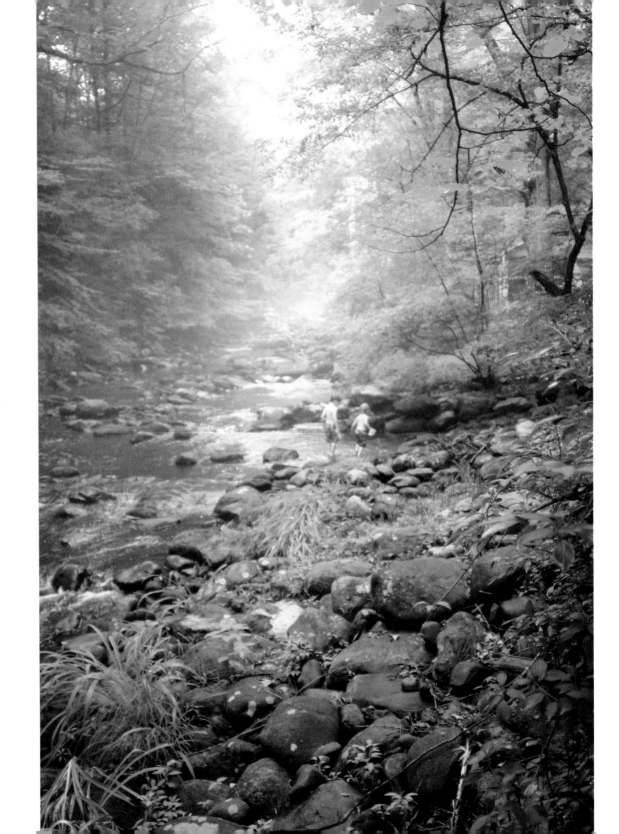

In summer, the song sings itself.

—William Carlos Williams

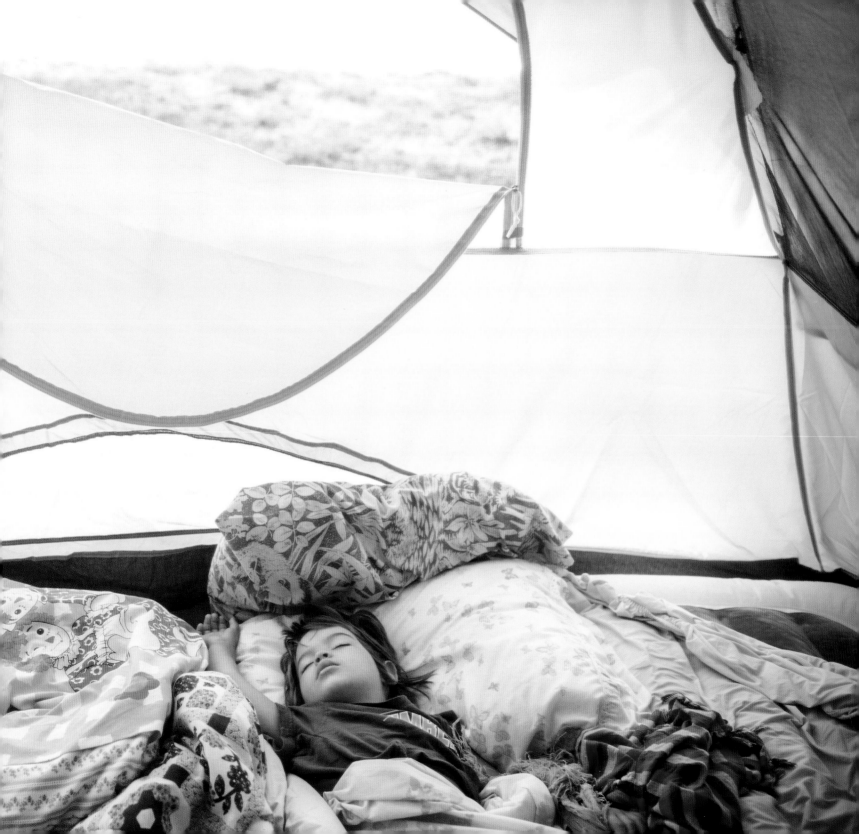

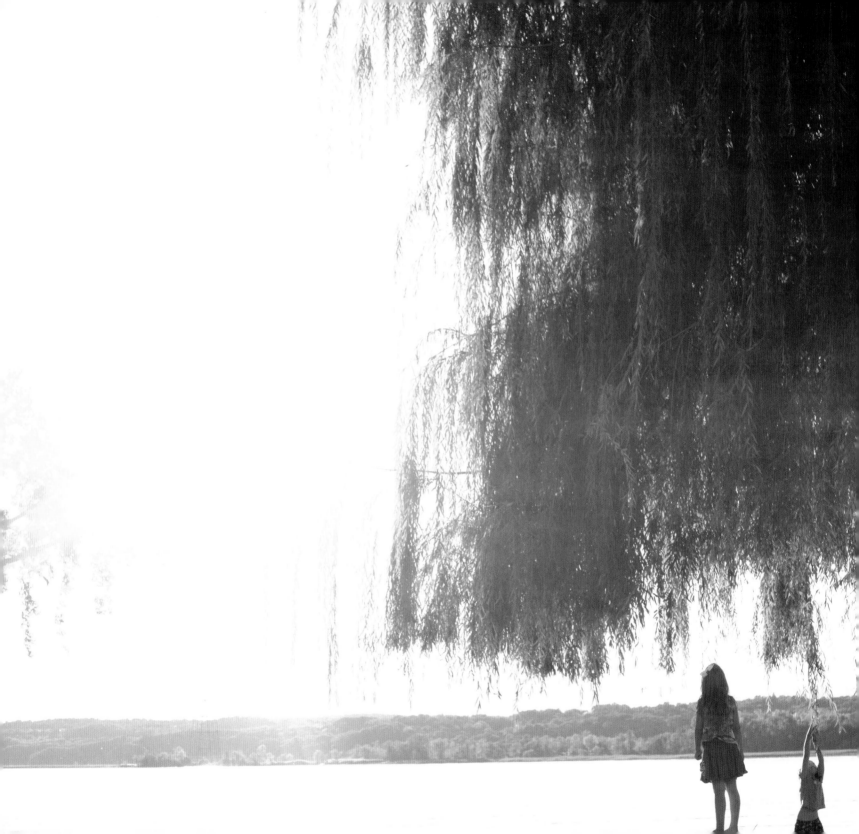

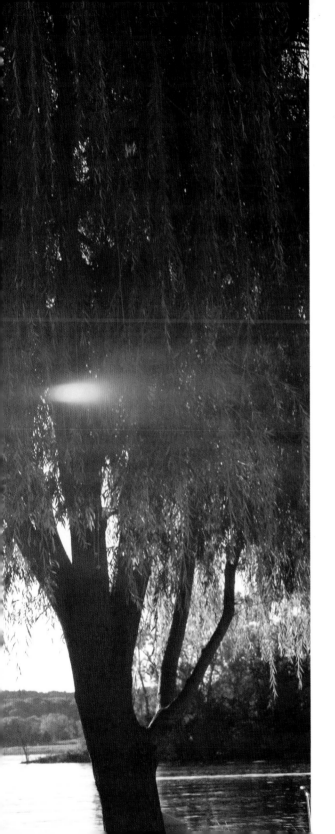

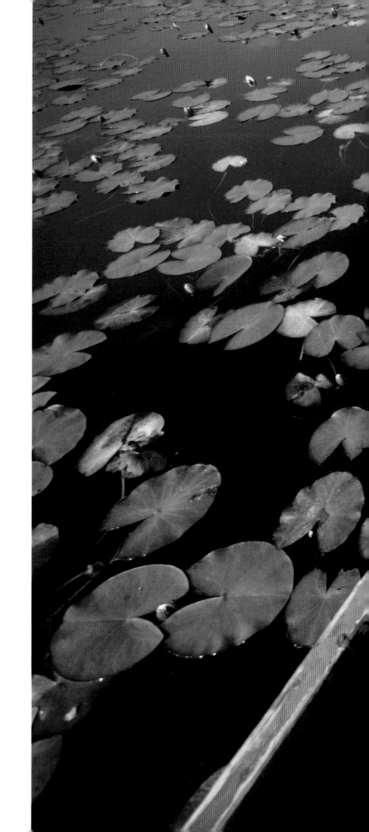

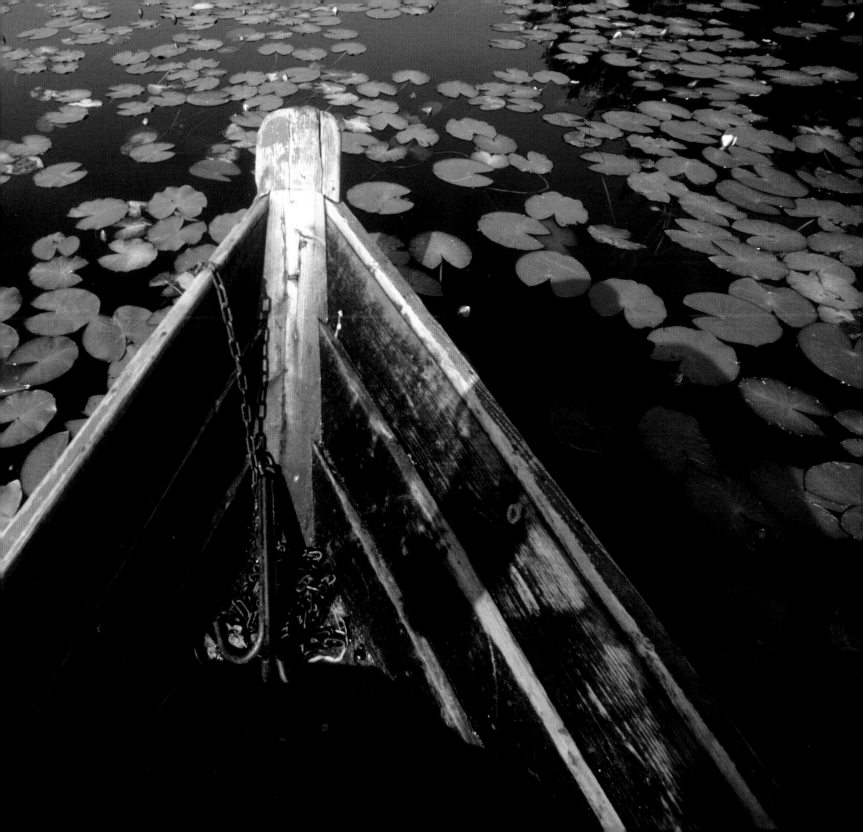

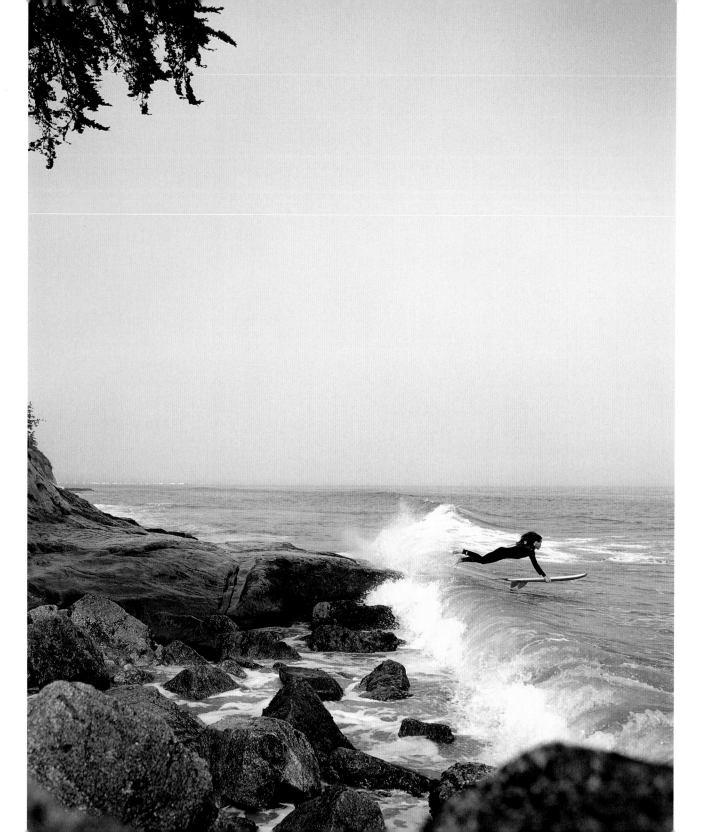

Following the light of the sun, we left the Old World.

—Christopher Columbus

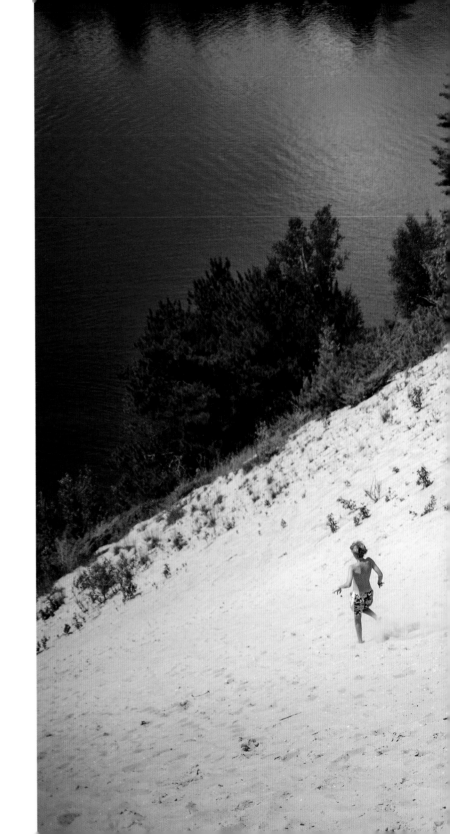

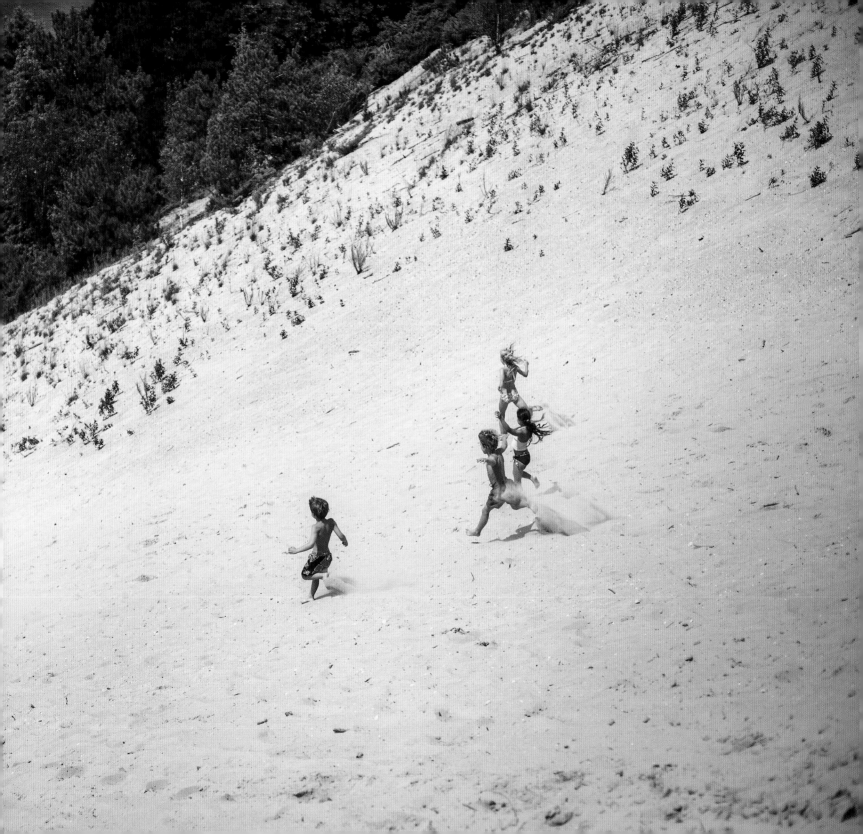

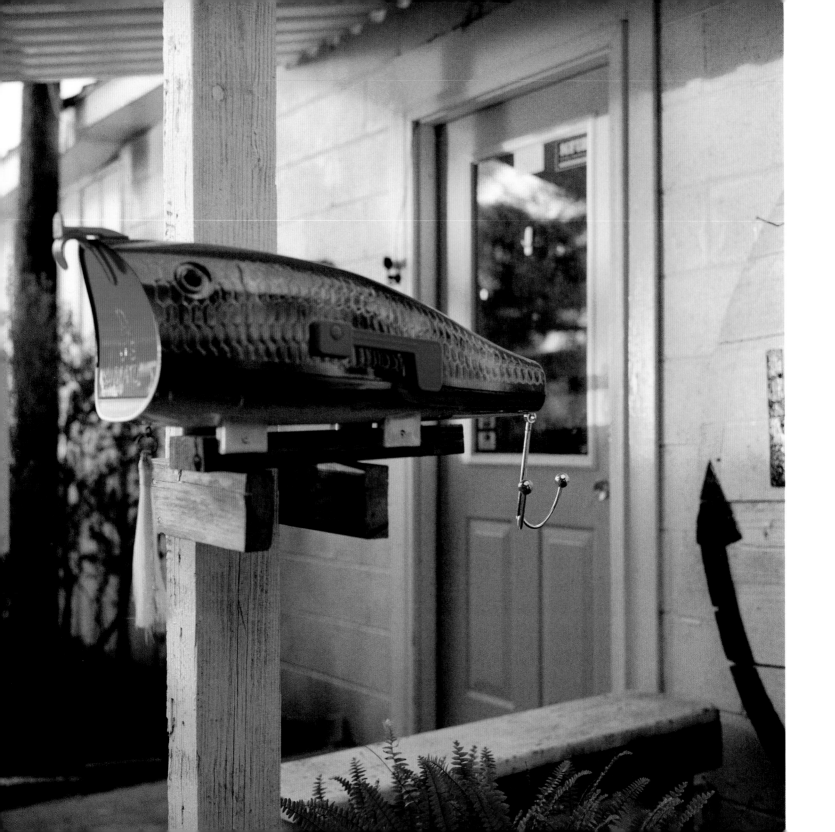

One's destination is never a place but rather a new way of looking at things.

—Henry Miller

They say the sea is cold, but the sea contains
the hottest blood of all, and the wildest, the most urgent.

—D. H. Lawrence

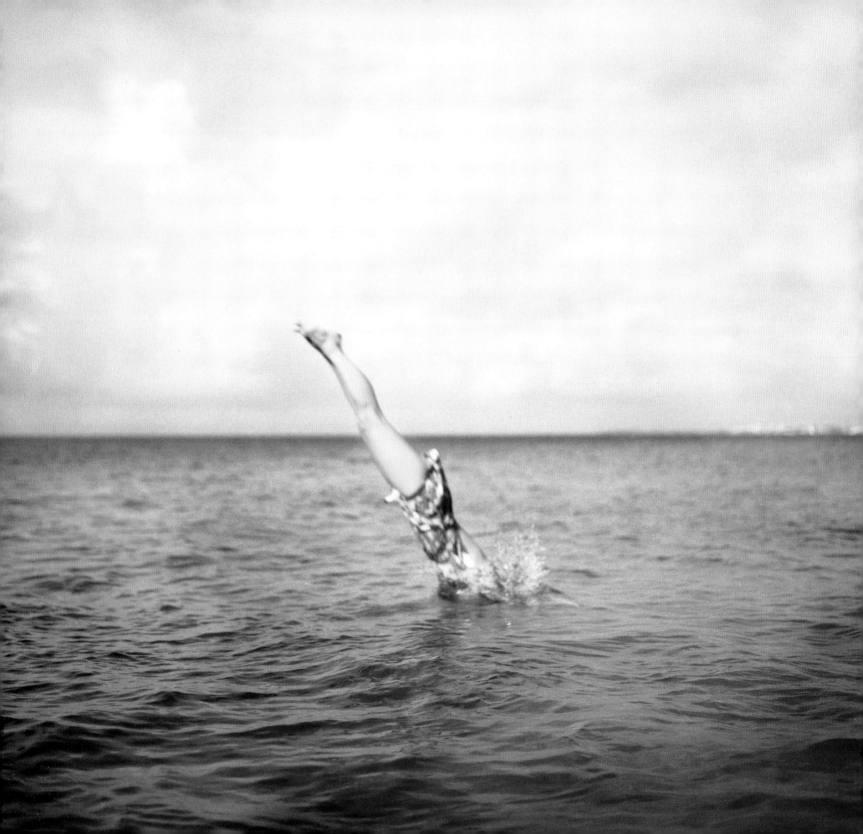

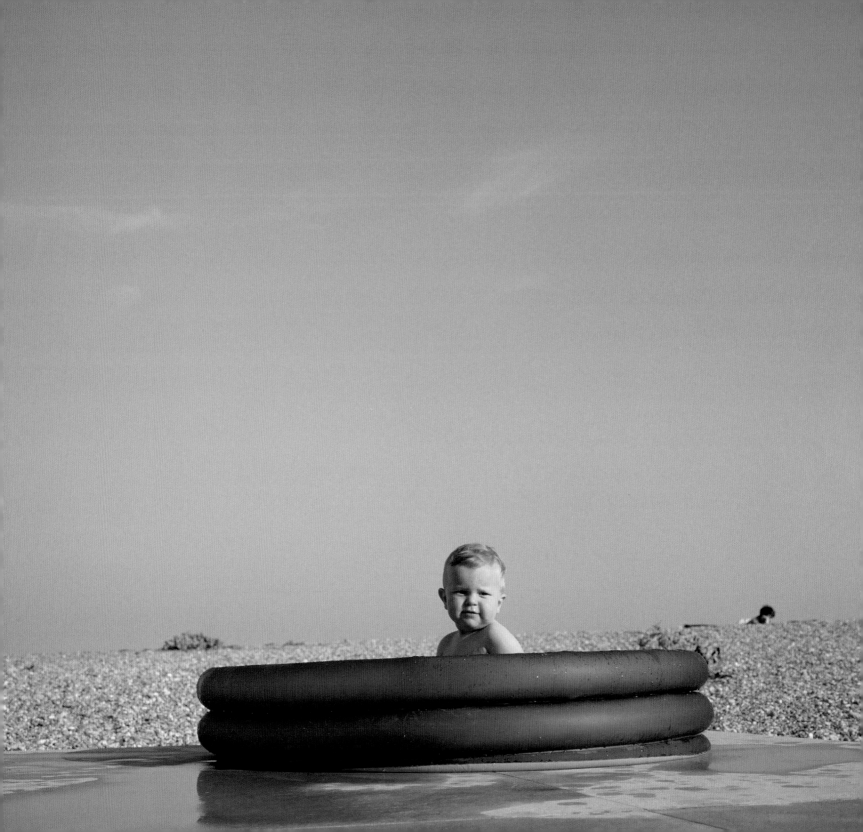

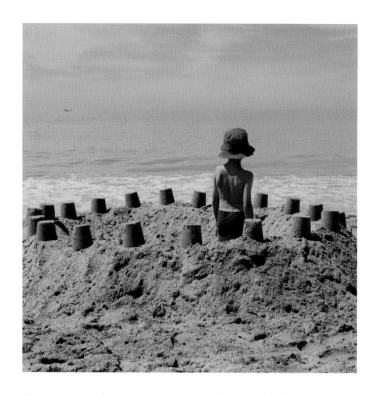

I do not know what I may appear to the world, but to myself I seem to have been only like a boy playing on the sea-shore, and diverting myself in now and then finding a smoother pebble or prettier shell than ordinary, whilst the great ocean of truth lay all undiscovered before me.

—Isaac Newton

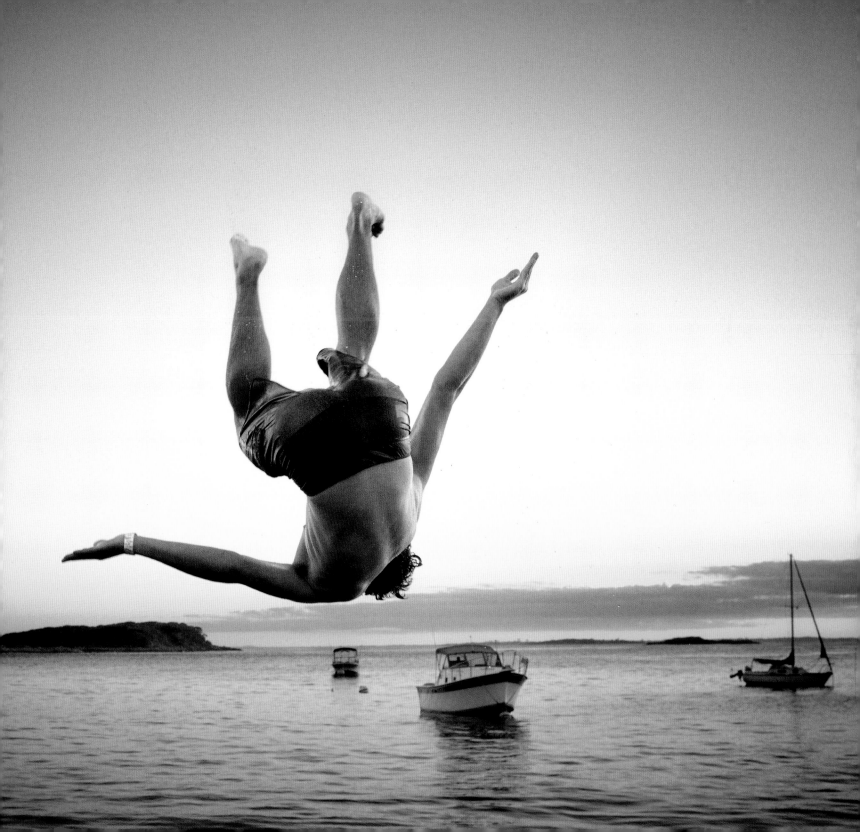

Summer night—
even the stars
are whispering to each other.

—Kobayashi Issa

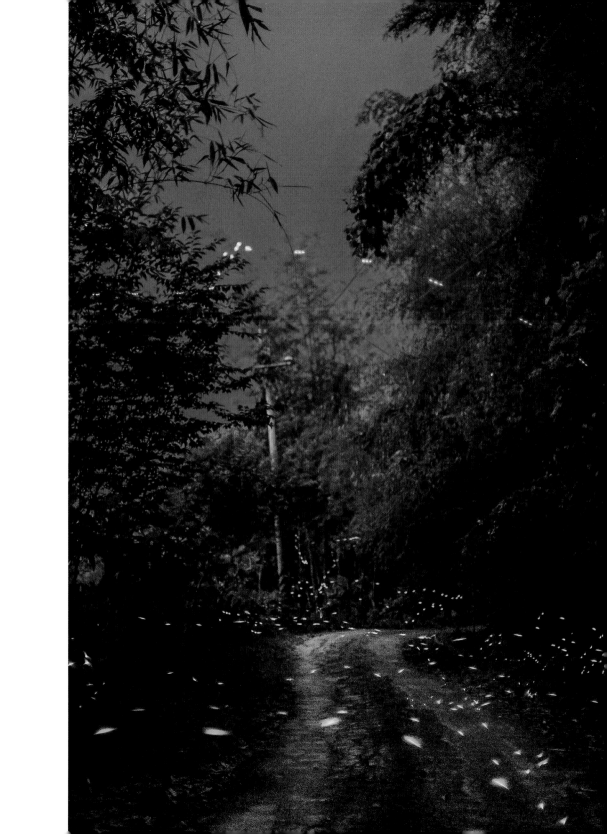

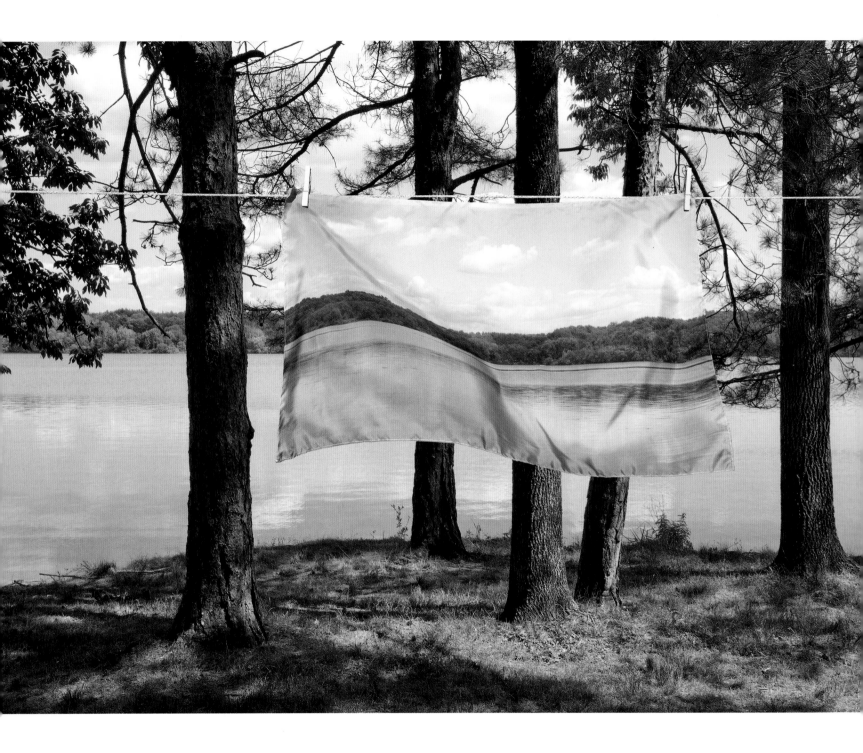

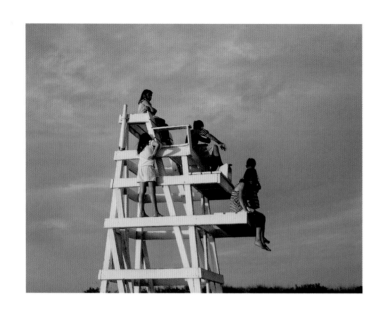

We are tied to the ocean. And when we go back to the sea, whether it is to sail or watch it, we are going back from whence we came.

—John F. Kennedy

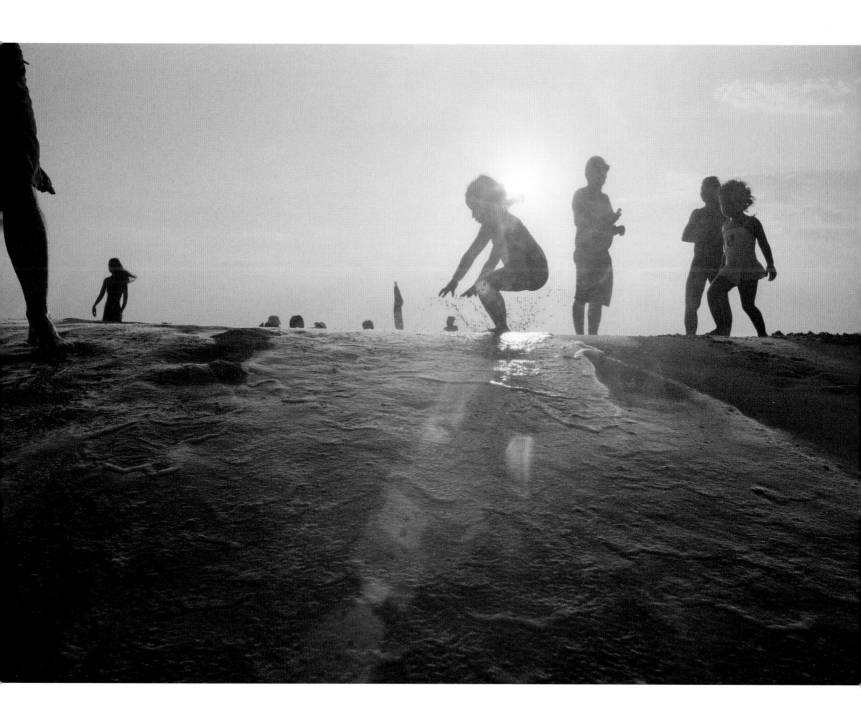

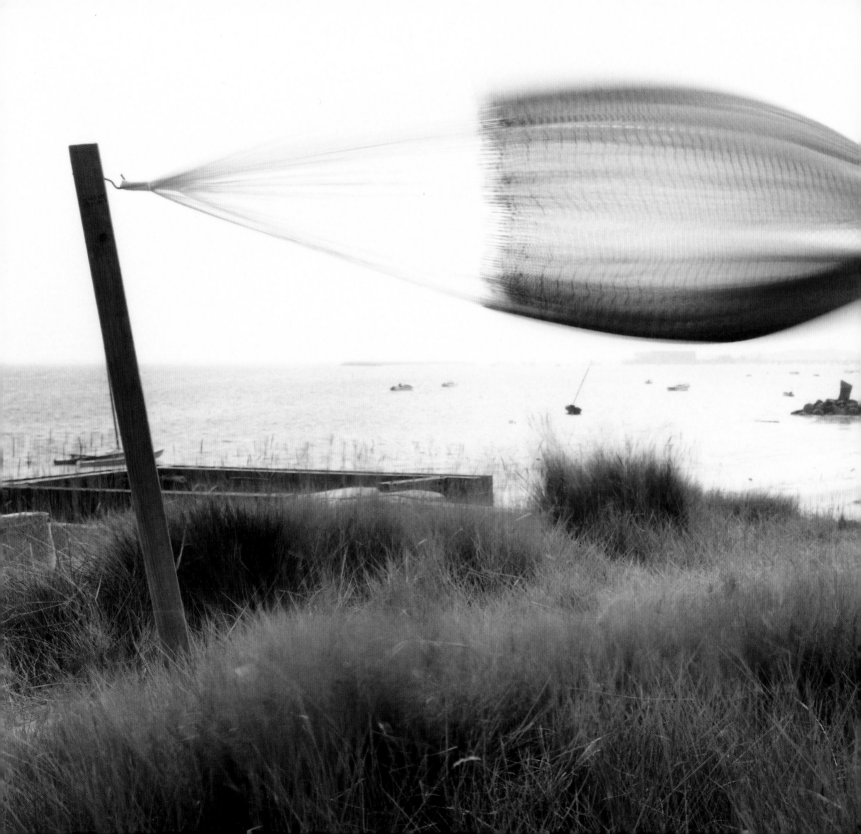

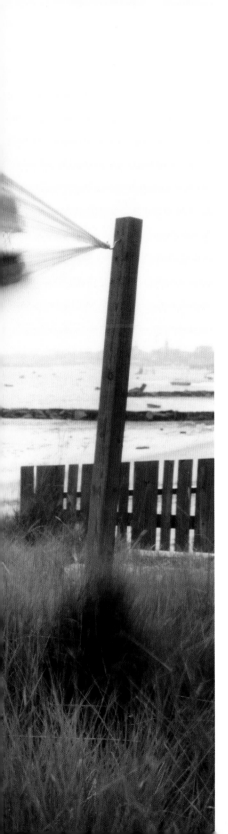

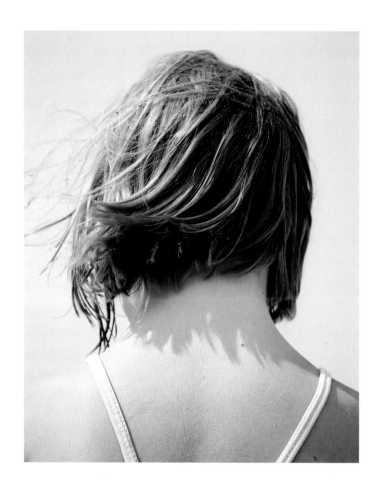

I was never less alone than when by myself.

—Edward Gibbon

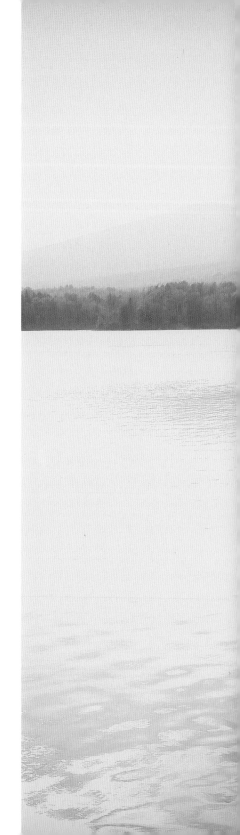

Perhaps that other life is contrast always to this.

—Hilda Doolittle

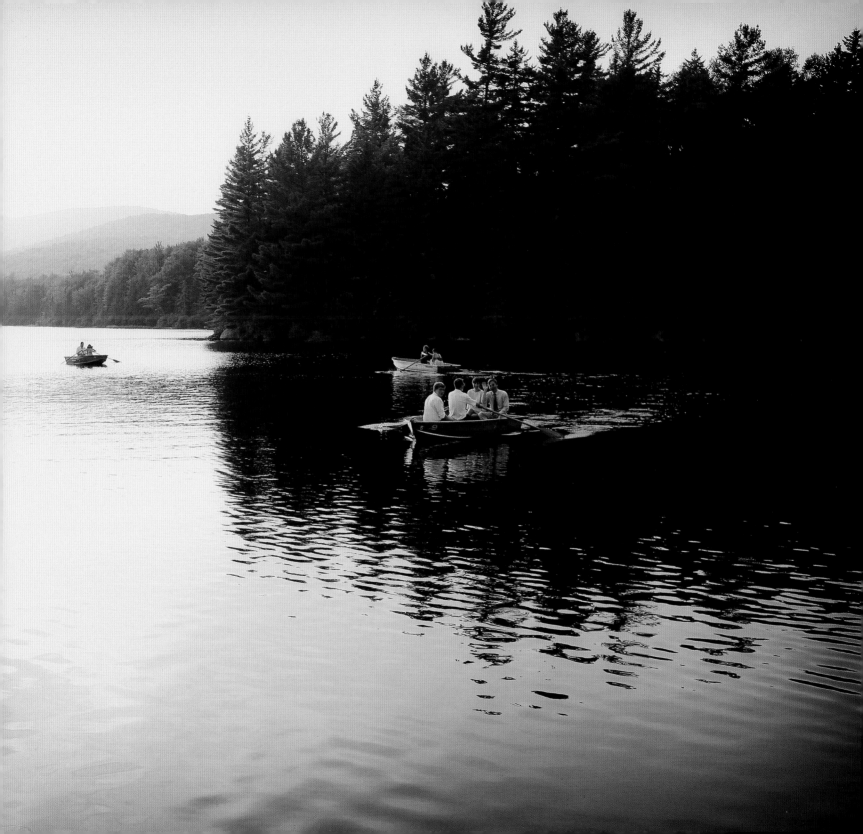

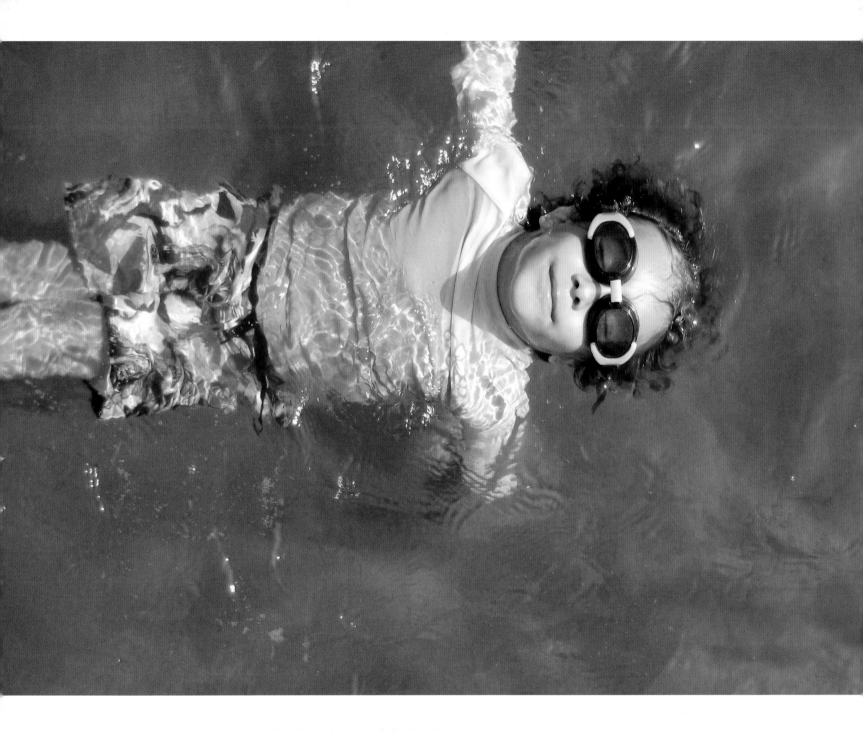

Give me the splendid silent sun with all his beams full-dazzling.

—Walt Whitman

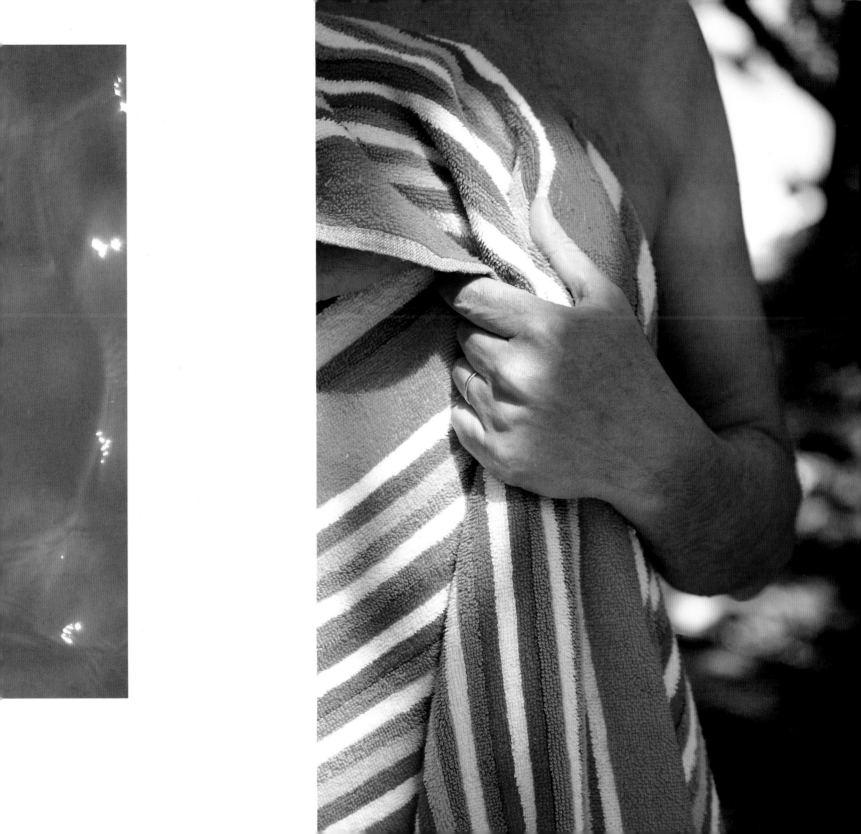

See the blue pools in the squinting sun
Hear the hissing of summer lawns

—Joni Mitchell

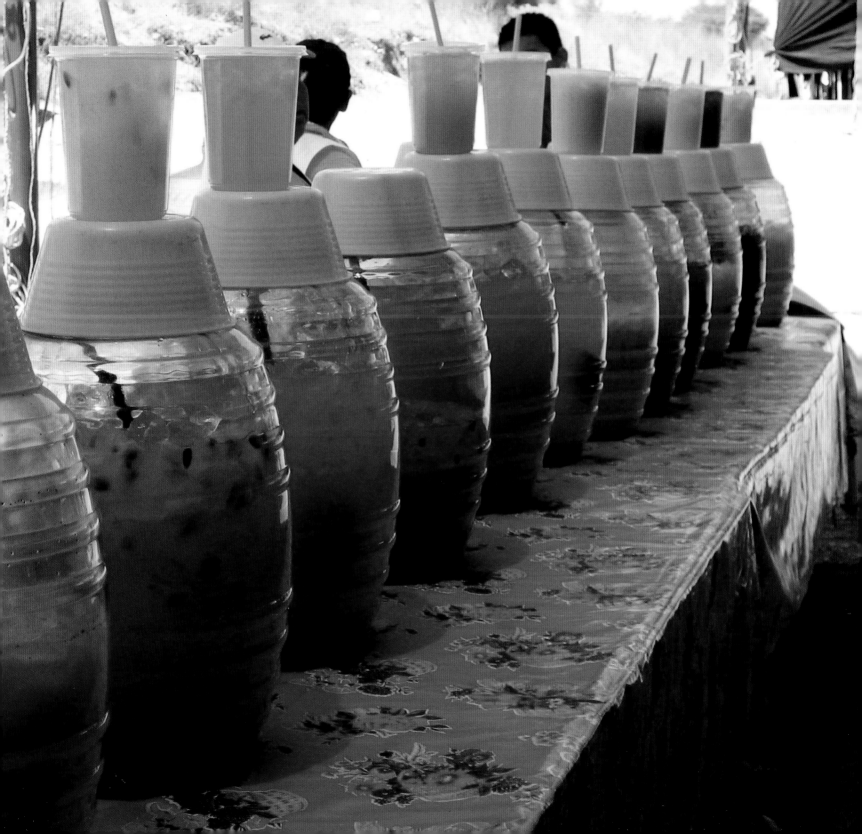

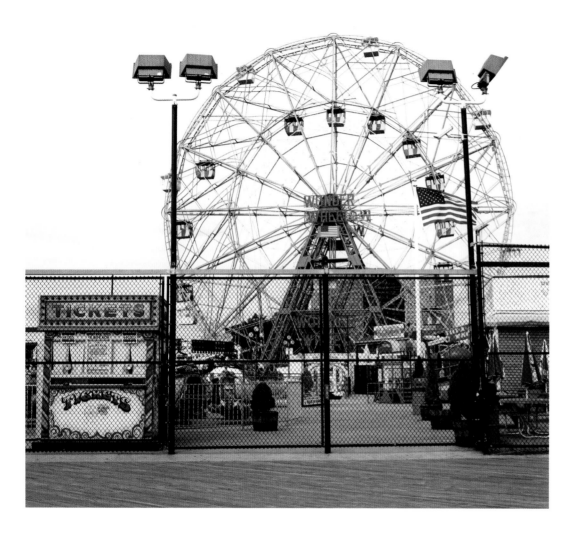

The summer that I was ten—
Can it be there was only one
summer that I was ten?

 —May Swenson

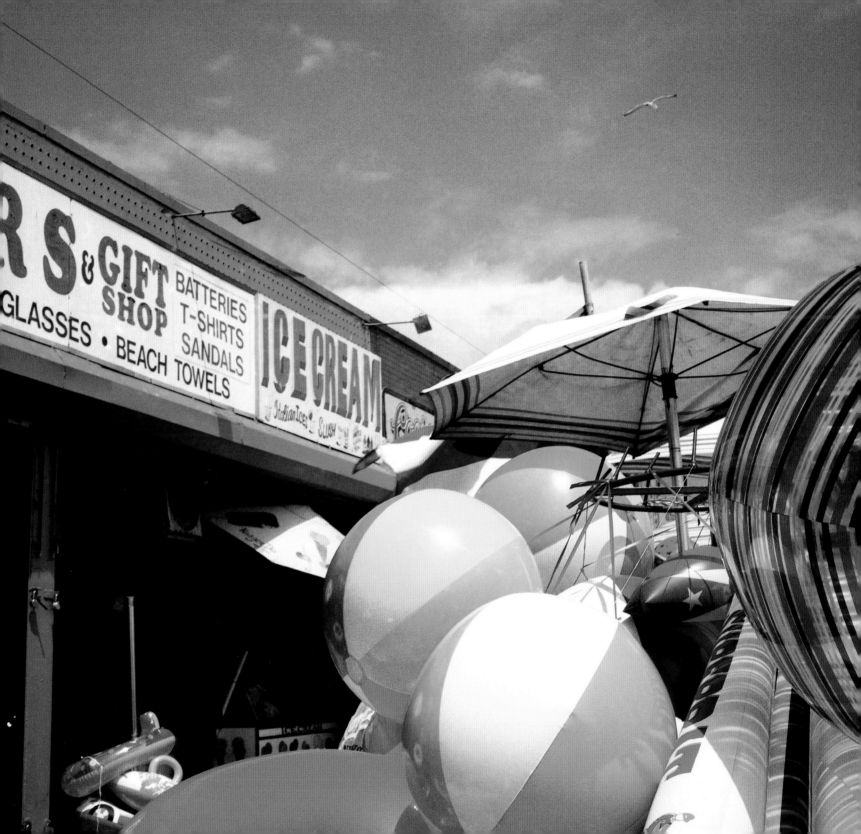

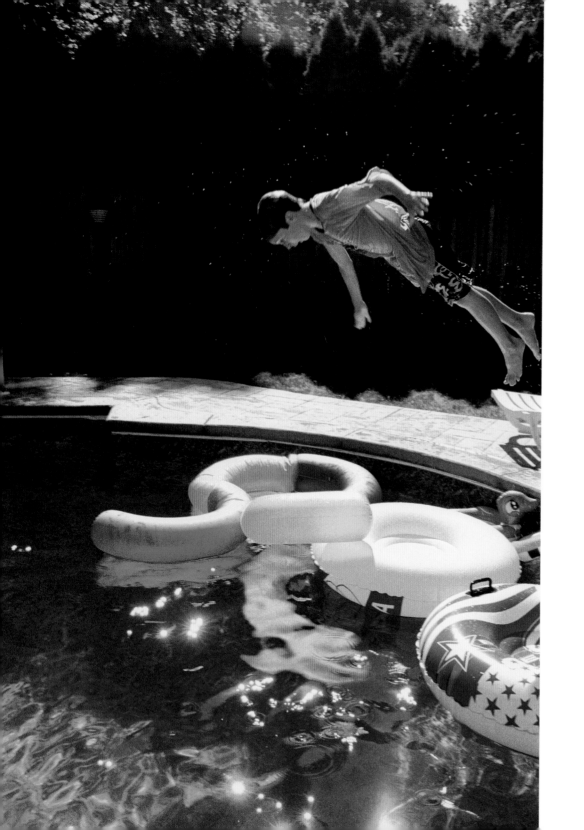

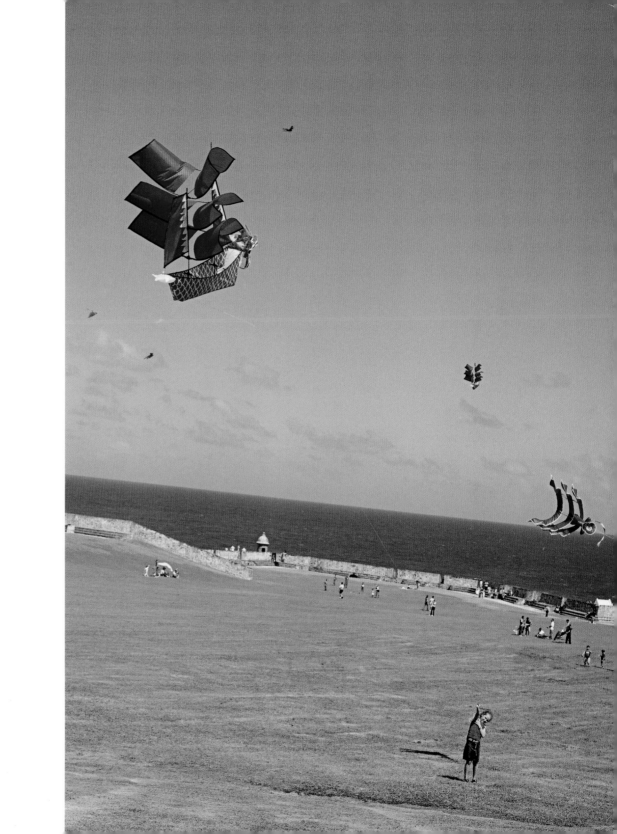

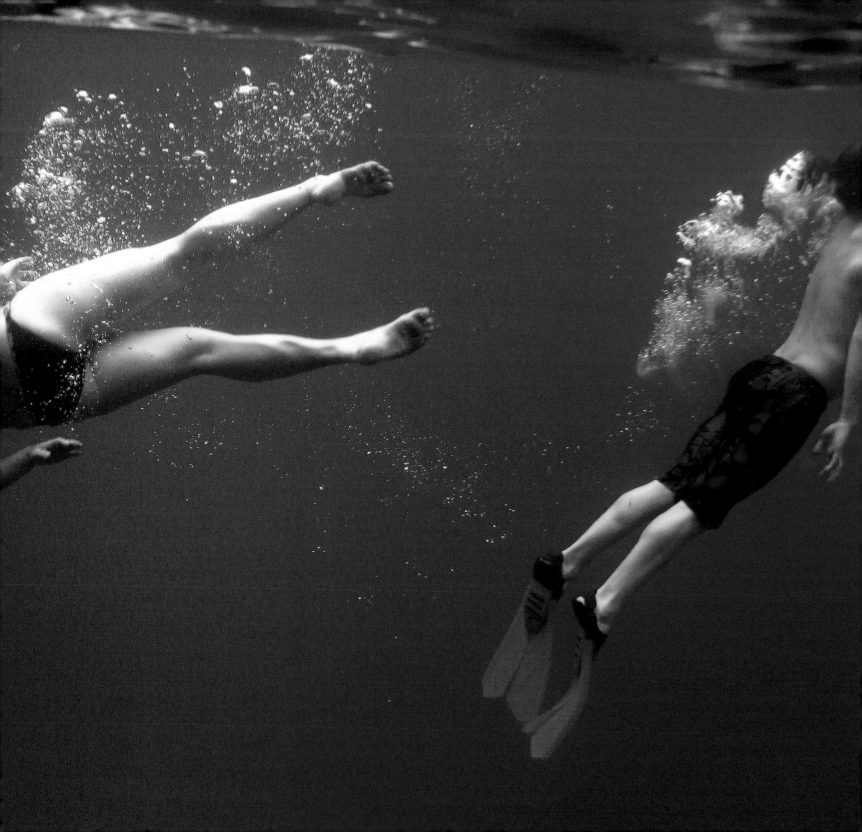

The sea, once it casts its spell,
holds one in its net of wonder forever.

—Jacques Cousteau

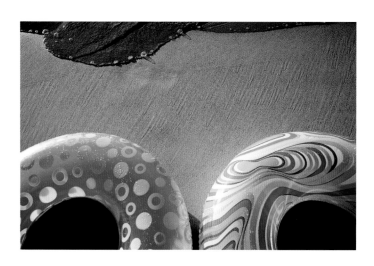

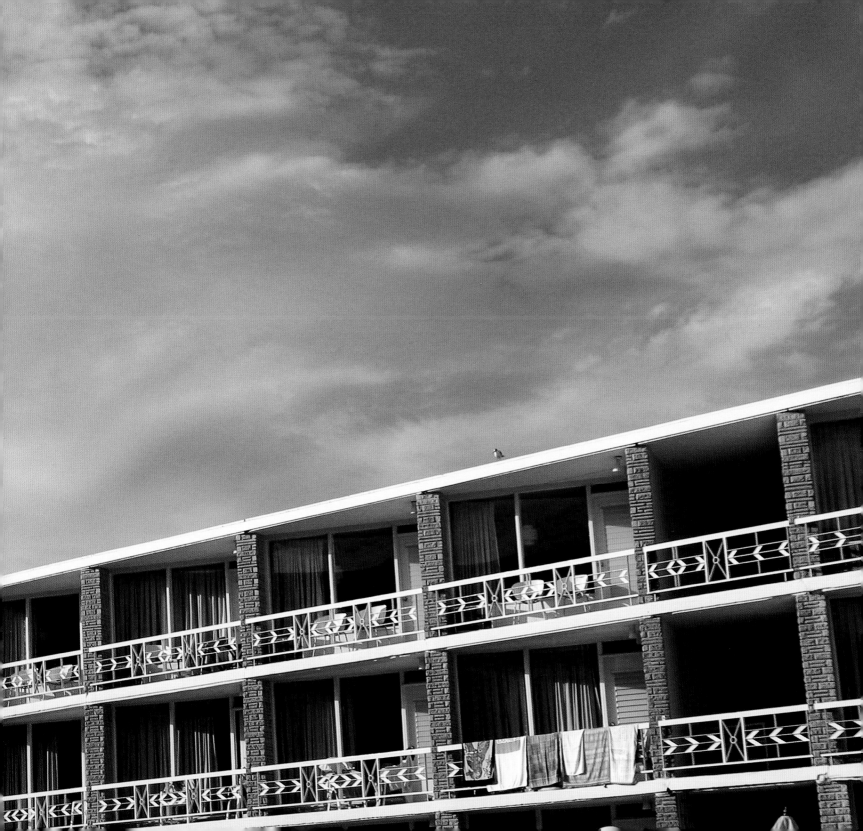

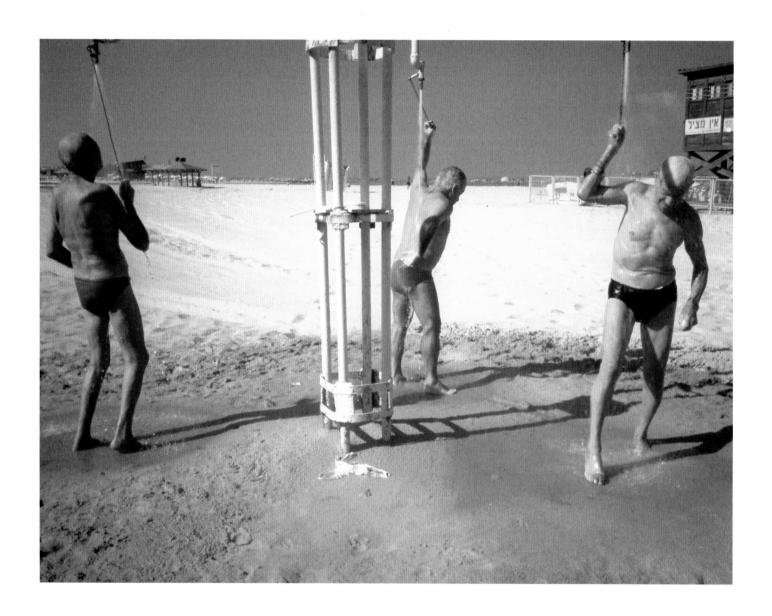

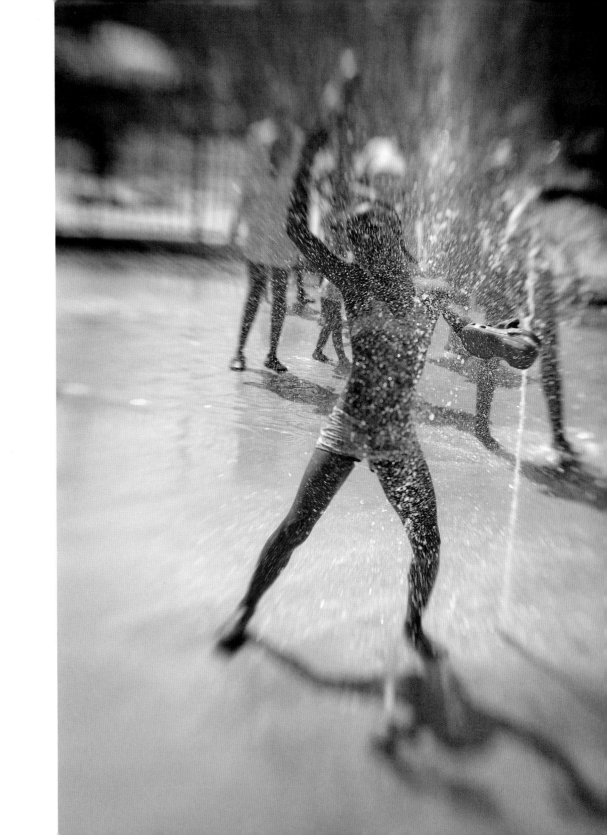

To see the Summer Sky
Is Poetry, though never in a Book it lie—
True Poems flee—

—Emily Dickinson

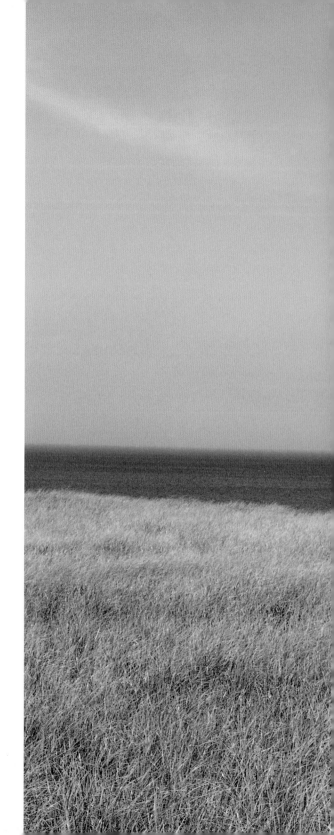

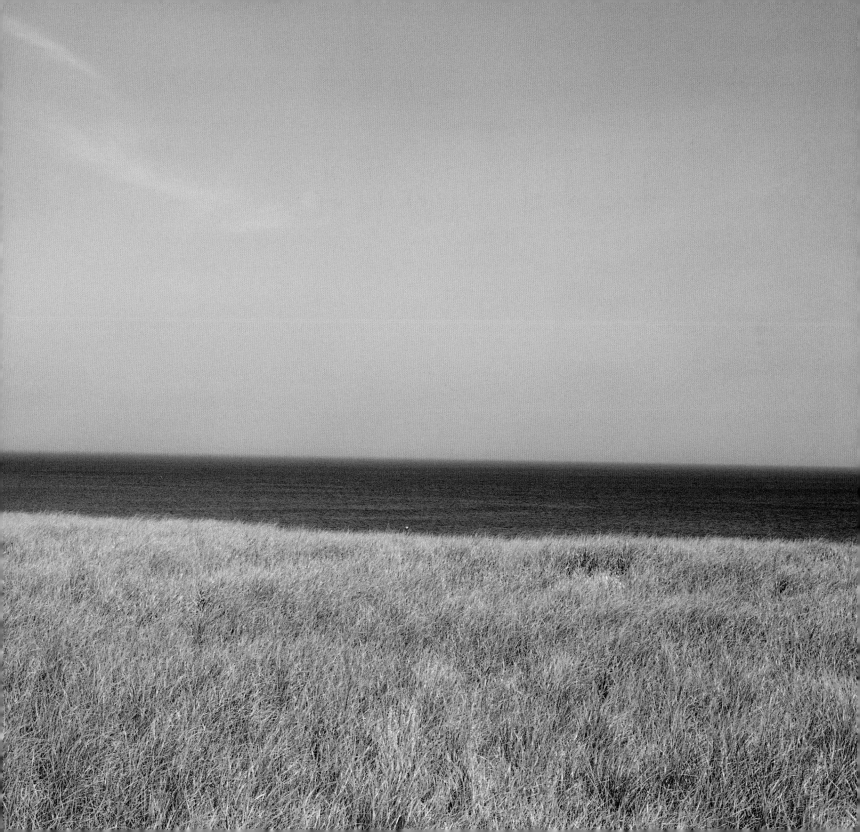

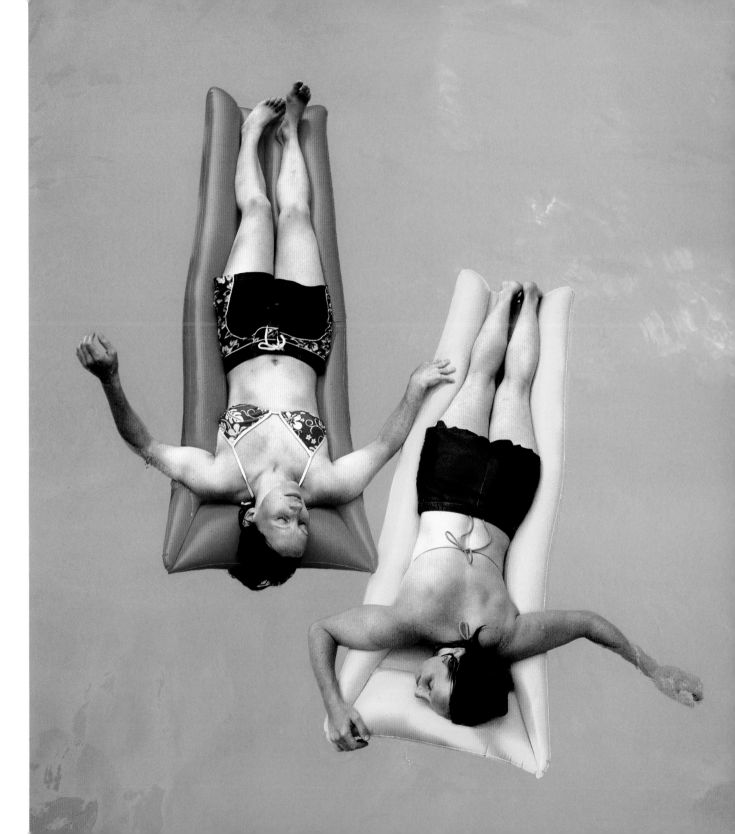

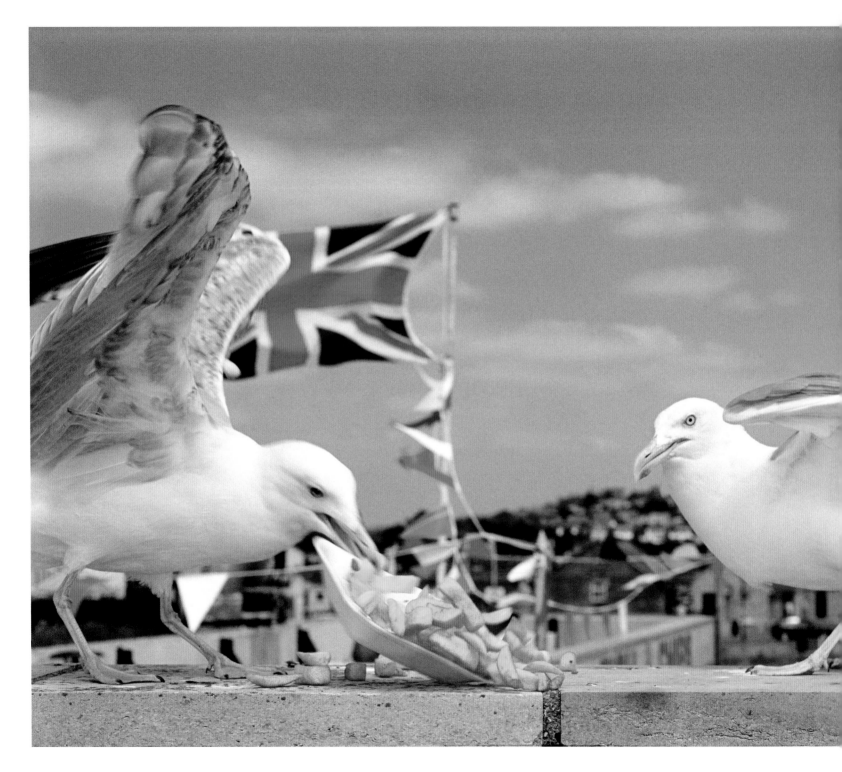

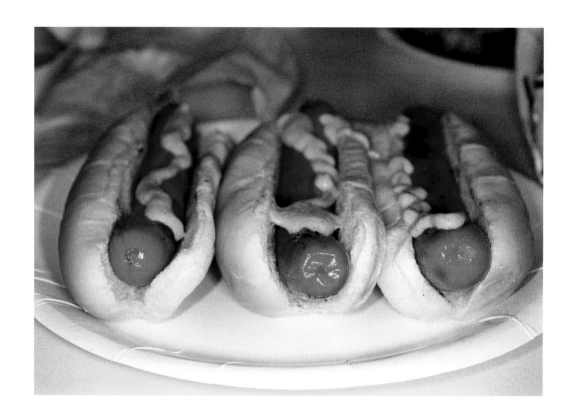

Is it so small a thing
To have enjoy'd the sun?

—Matthew Arnold

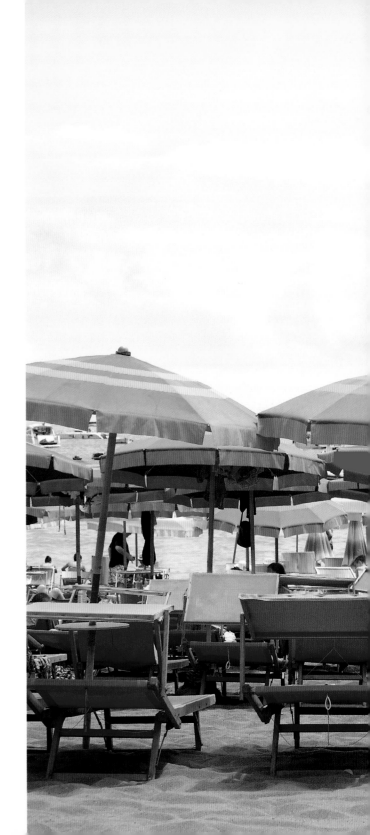

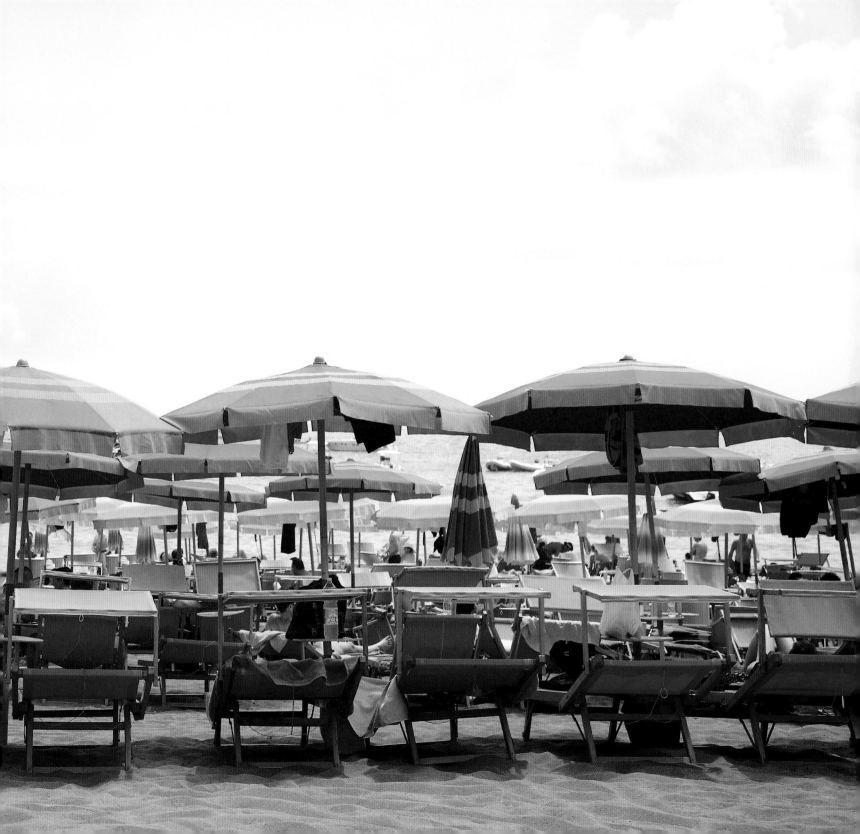

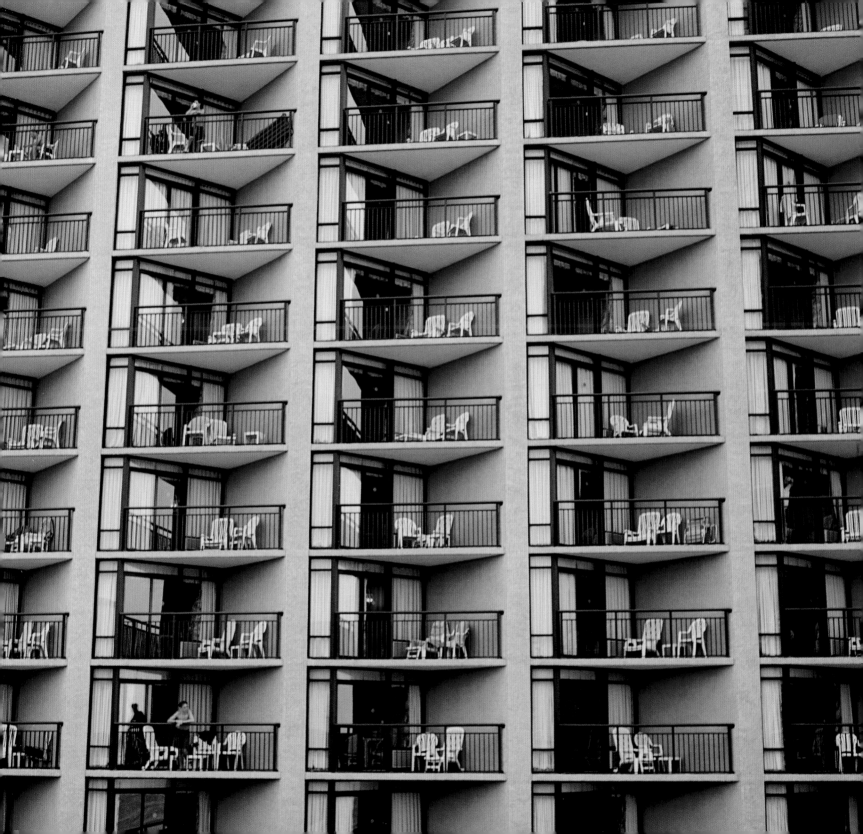

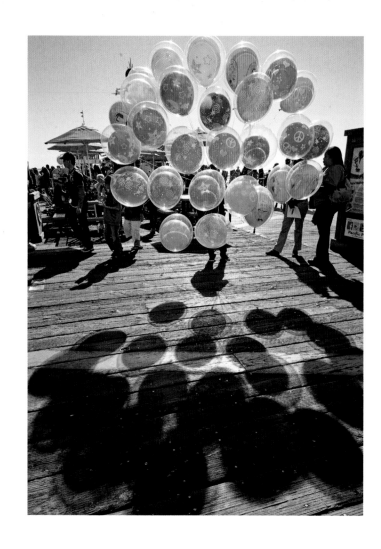

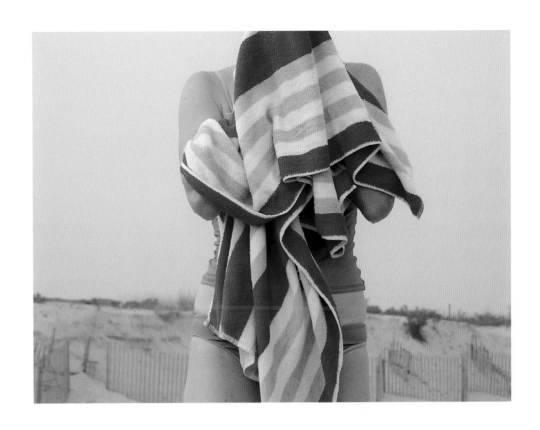

Let us consider the way in which we
spend our lives.

—Henry David Thoreau

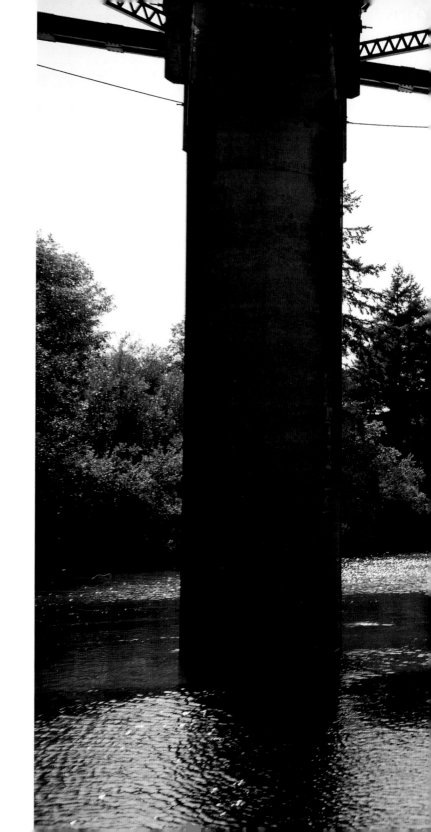

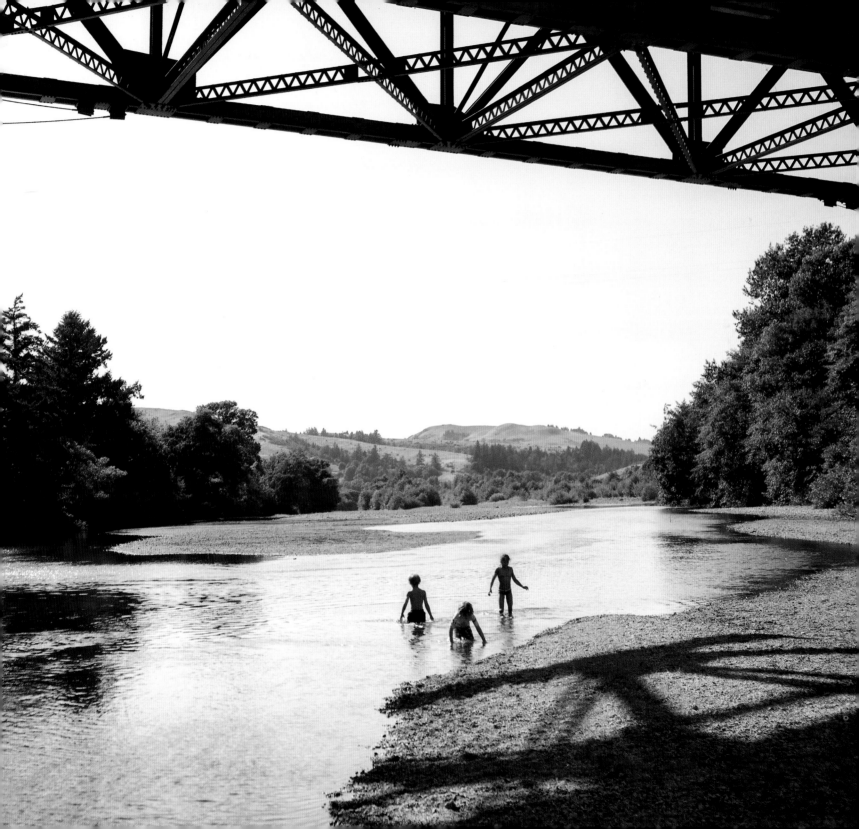

Summer afternoon—summer afternoon;
to me those have always been the two most
beautiful words in the English language.

—Henry James

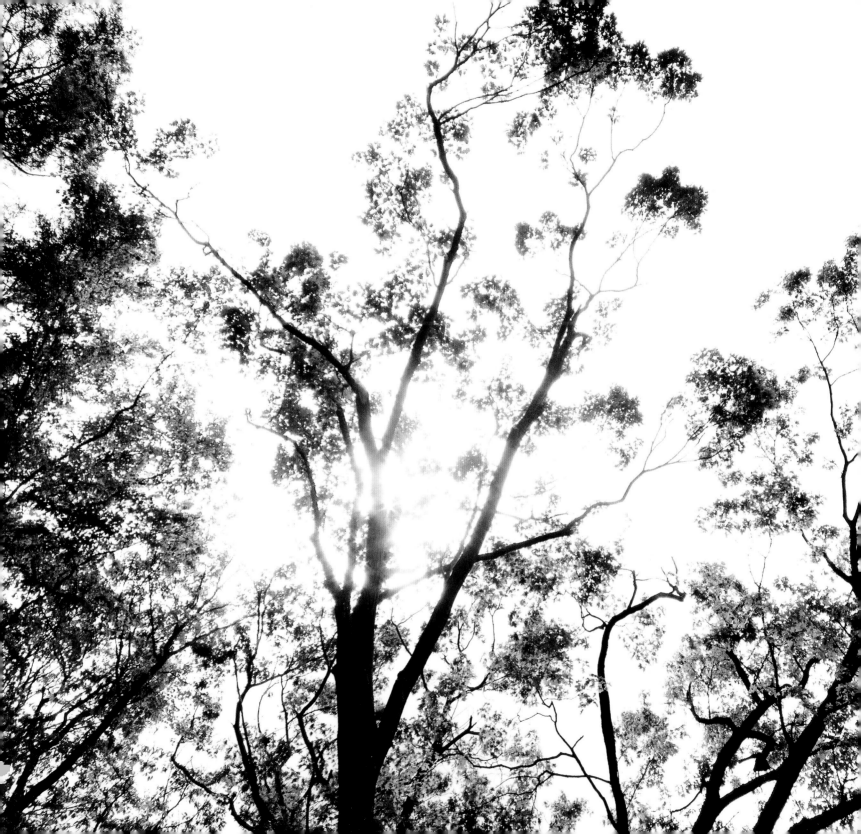

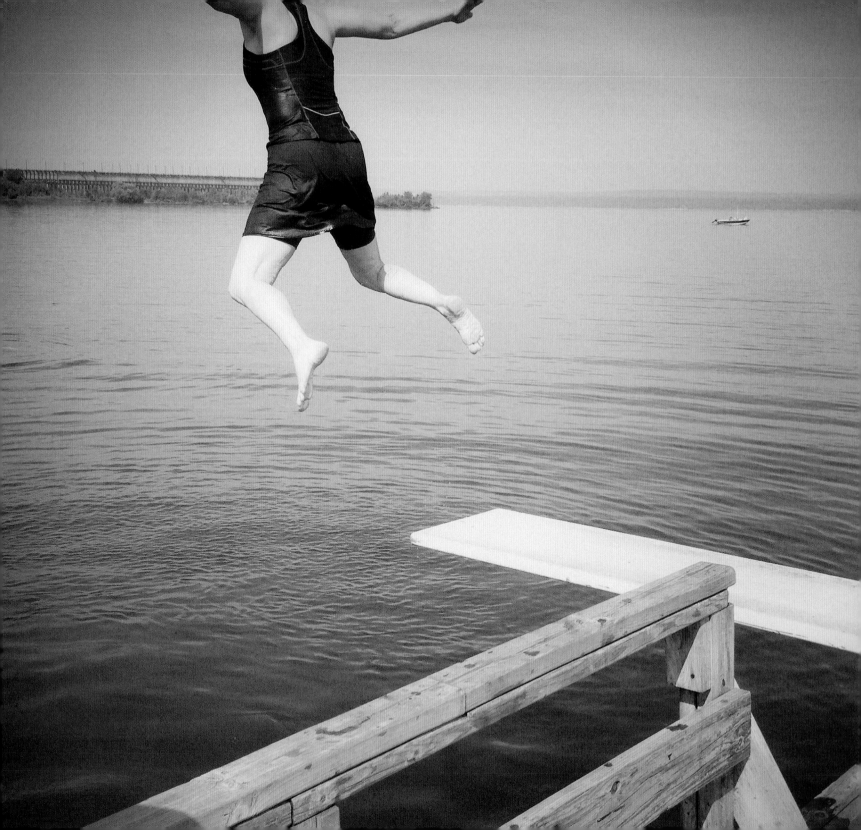

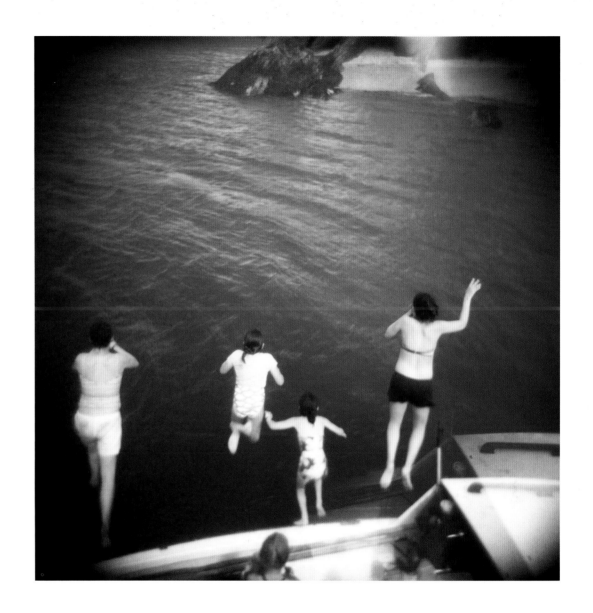

Live in the sunshine,
swim in the sea,
drink the wild air.

—Ralph Waldo Emerson

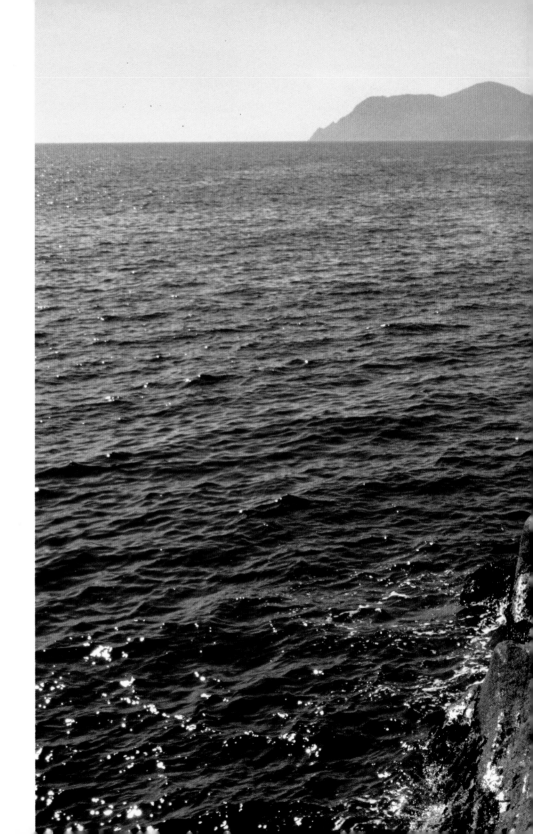

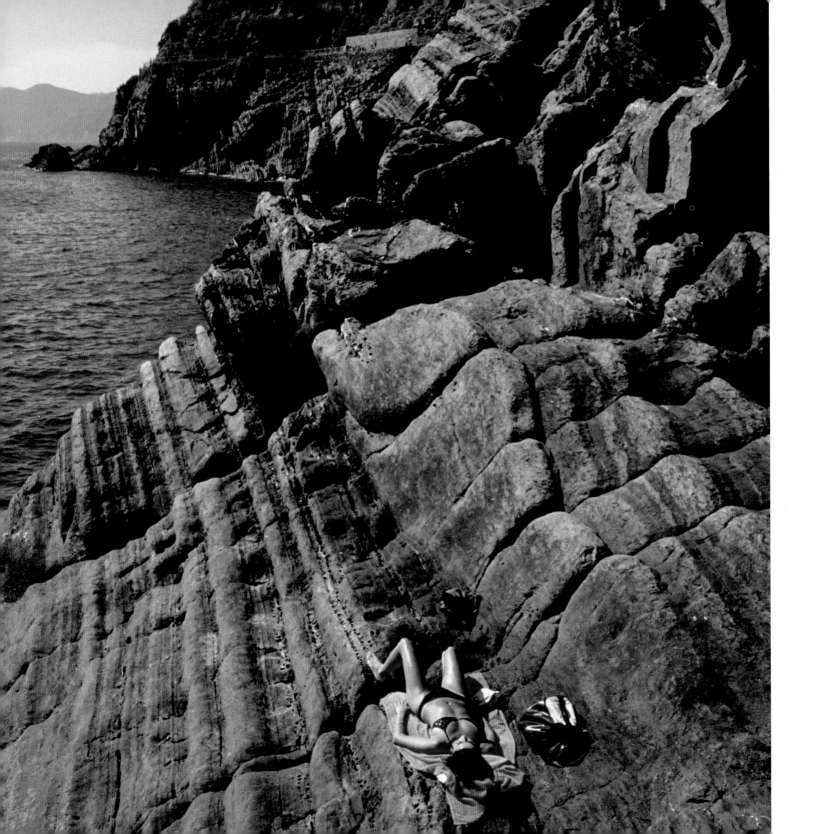

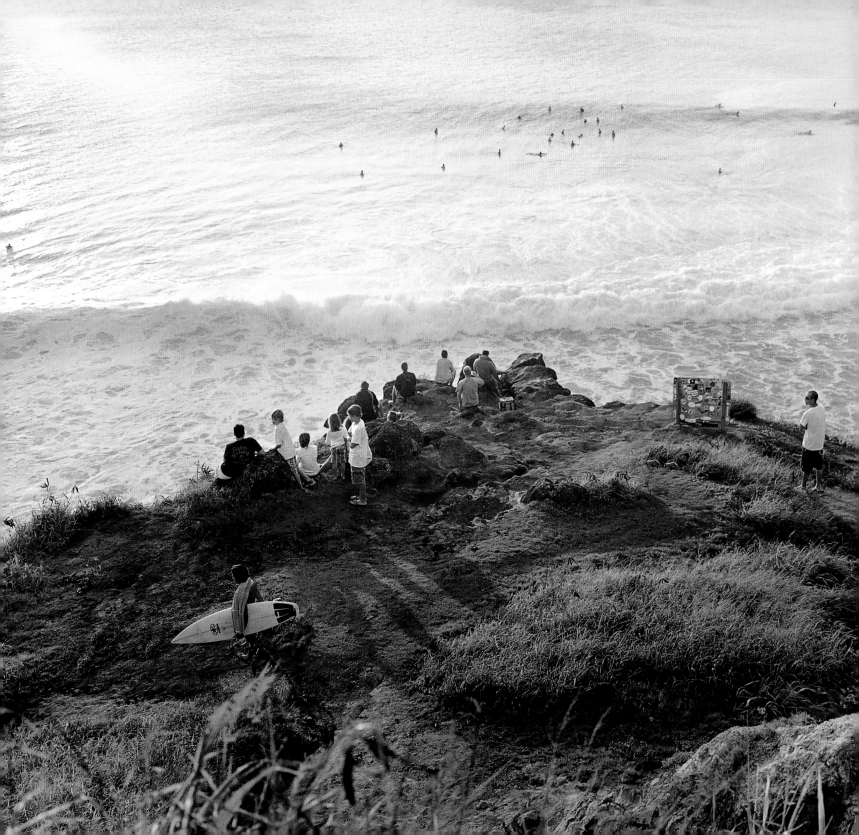

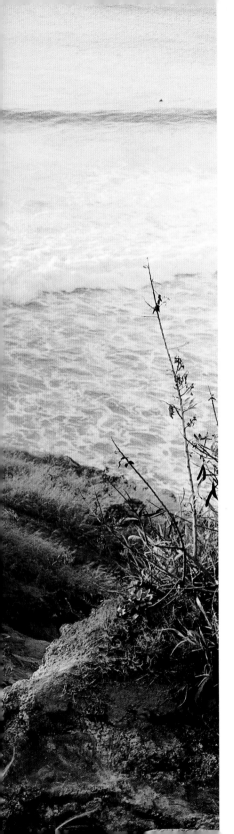

On the face of the waters
A wind moves
Making waves

 —Gary Snyder

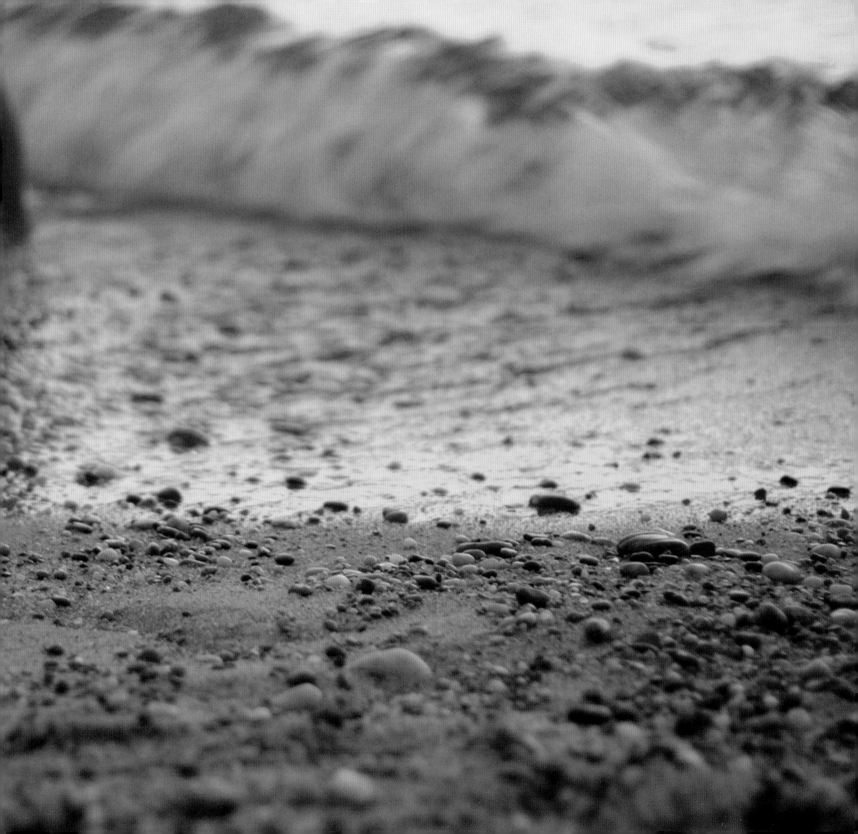

Nothing before and nothing behind but the sky and the ocean.

—Friedrich Schiller

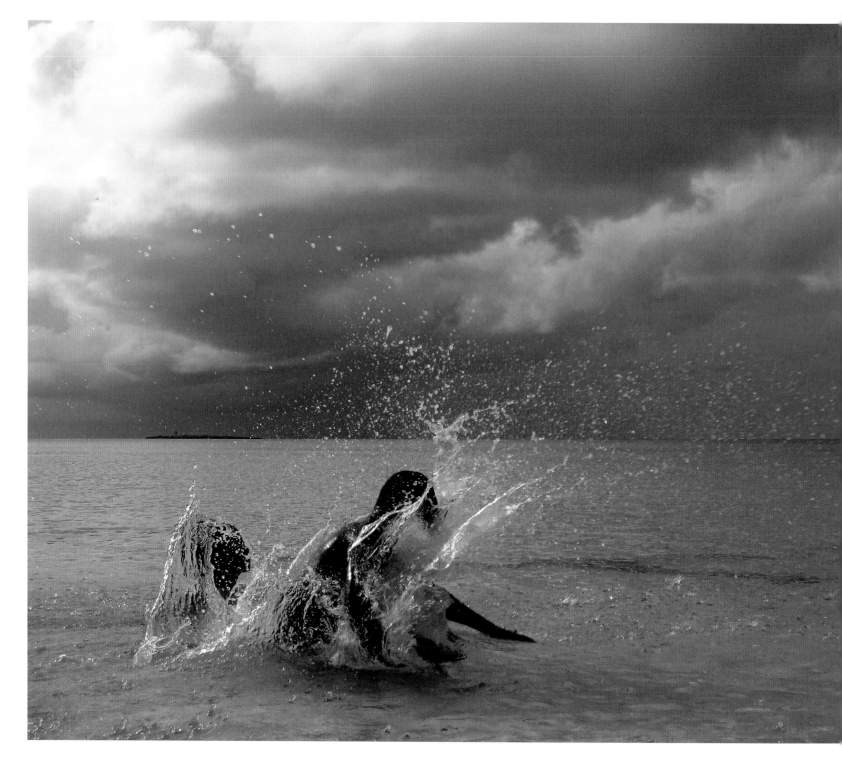

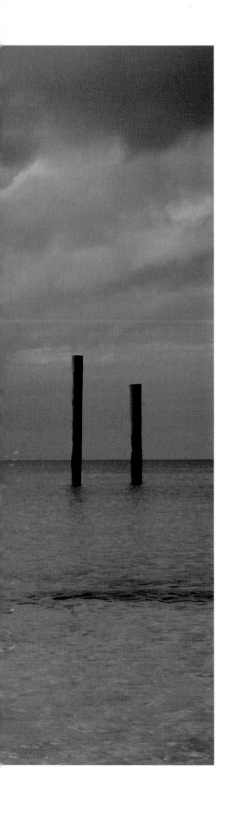

But thy eternal summer shall not fade.

—William Shakespeare

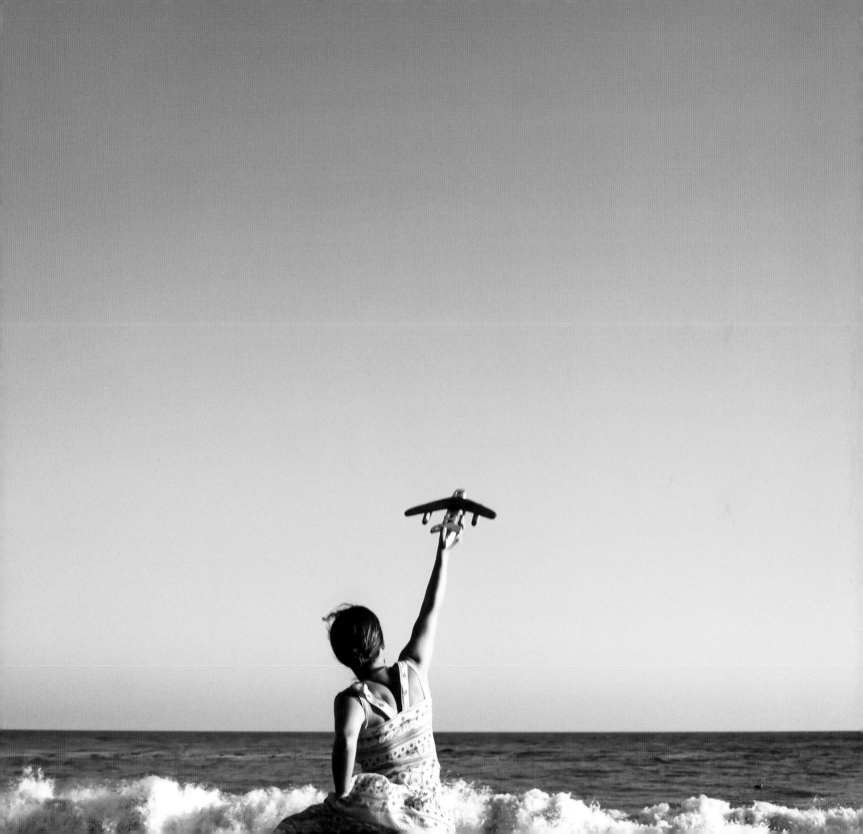

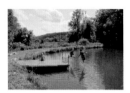

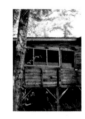
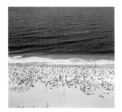
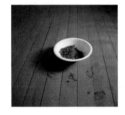
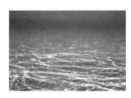
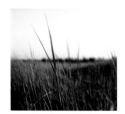
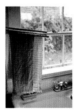
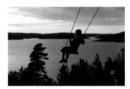
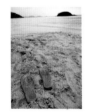

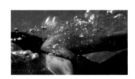
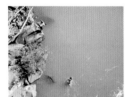
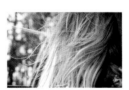
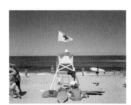

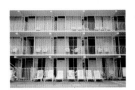

Page 36–37

Doors, Wildwood, NJ
© 2007 Joanne Dugan
www.joannedugan.com

Page 46–47

Floating Reds
© 1985 Roger Camp
All Rights Reserved
www.rogercampphoto.com

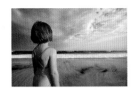

Page 56–57

Girl on Beach
© Jens Honoré

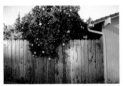

Page 38–39

Untitled (Santa Barbara)
© 2009 Liz Kuball
www.lizkuball.com

Page 48

*Day Cottage View (Aster),
North Truro, MA*
© 2009 Joanne Dugan
www.joannedugan.com

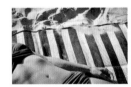

Page 58–59

Lucia, St. John
© 2010 Joanne Dugan
www.joannedugan.com

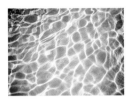

Page 40–41

Untitled
© 2013 charles gullung
photography
www.charlesgullung.com

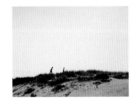

Page 49

*Ludovic and Hugo at Longnook,
Truro, MA*
© 2009 Joanne Dugan
www.joannedugan.com

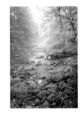

Page 61

Max in Brook Age 2
© 2013 Jayne Hinds Bidaut,
NYC
www.jaynehindsbidaut.com

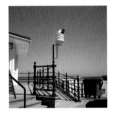

Page 42

*G.B. England, Margate, A
Portrayal of a Traditional
English Seaside Resort, 2002*
© Peter Marlow,
Magnum Photos
www.petermarlow.com

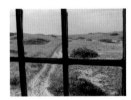

Page 50–51

*View from C-Scape,
Provincetown*
© Jane Paradise
www.janeparadise.com

Page 62–63

Untitled
© 2013 charles gullung
photography
www.charlesgullung.com

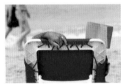

Page 42–43

*Man Reading in Beach Chair in
Barbados*
© 2010 Bo Zaunders
www.bozaunders.com

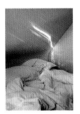

Page 53

*Bernard and Hugette's House,
Châteaubriant*
© 2010 Joanne Dugan
www.joannedugan.com

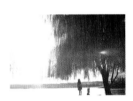

Page 64–65

Last Days of Summer
© 2012 Georgia Kokolis
www.georgiakokolis.com

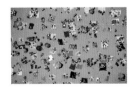

Page 44–45

Coney Island, 2006
© 2006 Vincent Laforet
www.laforetvisuals.com

Page 54–55

07.01.08 Cameron Beach Cut
© 2008 Blair Seagram
www.blairseagram.com

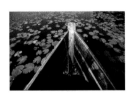

Page 66–67

*Rowboat and Water Lilies in
Rural Sweden*
© 1992 Bo Zaunders
www.bozaunders.com

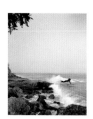
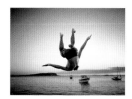
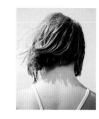
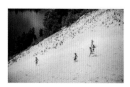

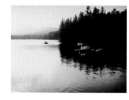
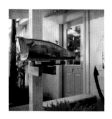
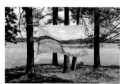

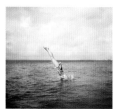
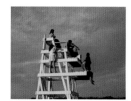

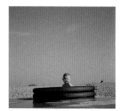
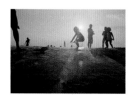

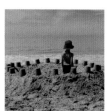
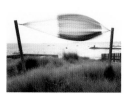
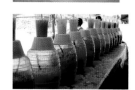

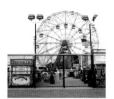

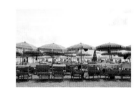
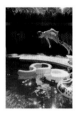
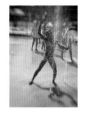
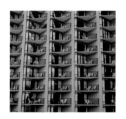

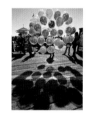
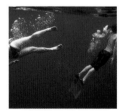
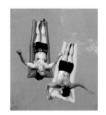

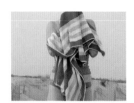
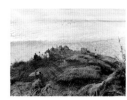
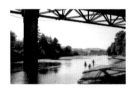
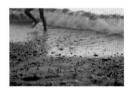

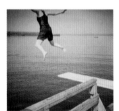
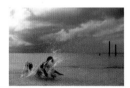
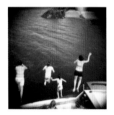
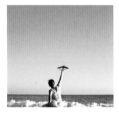
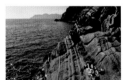

Quotation Credits

Summertime Acknowledgments

Deepest gratitude to all those who jumped in and swam with me:

Superlative editor: Sarah Malarkey

Supportive agent: Dan Kirschen

Talented designer: Sara Schneider

Consummate researcher: Alix Finkelstein

Right- (and sometimes left-) hand man: Kyle Orosz

Technical genius: Pascal Prince

Guiding counselor: Colin Graham

Men of summer and beyond: Ludovic and Hugo Moulin

Fully-knowing friends: Ann, Jackie, Gen, Ruth

Original summertime family: George, Marie, George, and Annette Dugan

Heartfelt thanks to the brilliant photographers, agents, galleries, authors, and publishers, who were kind enough to be involved and whose work will always inspire our views of summertime.